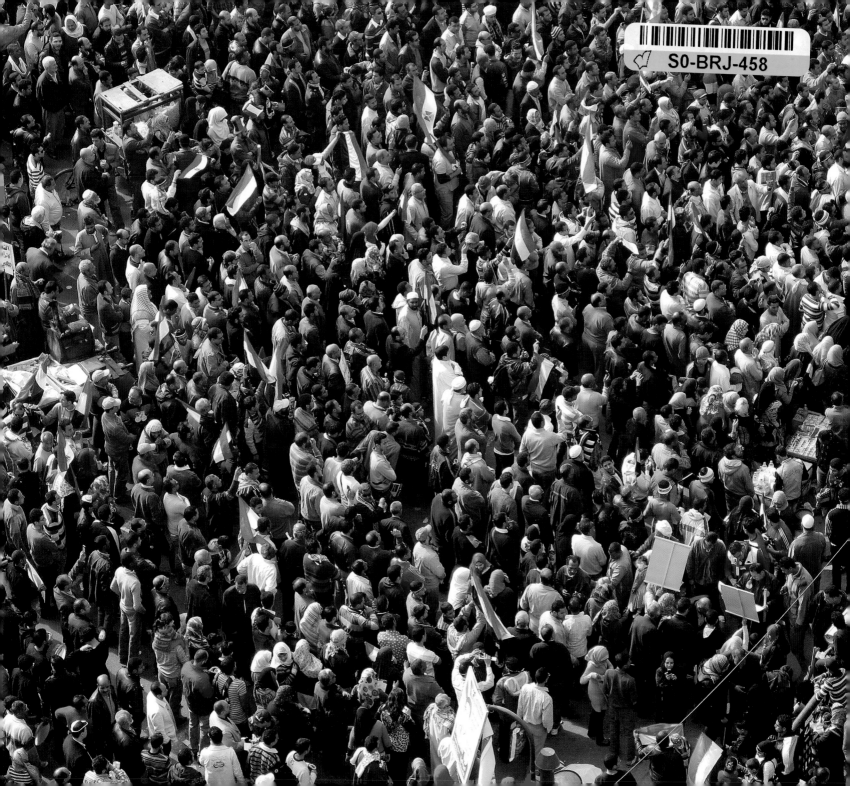

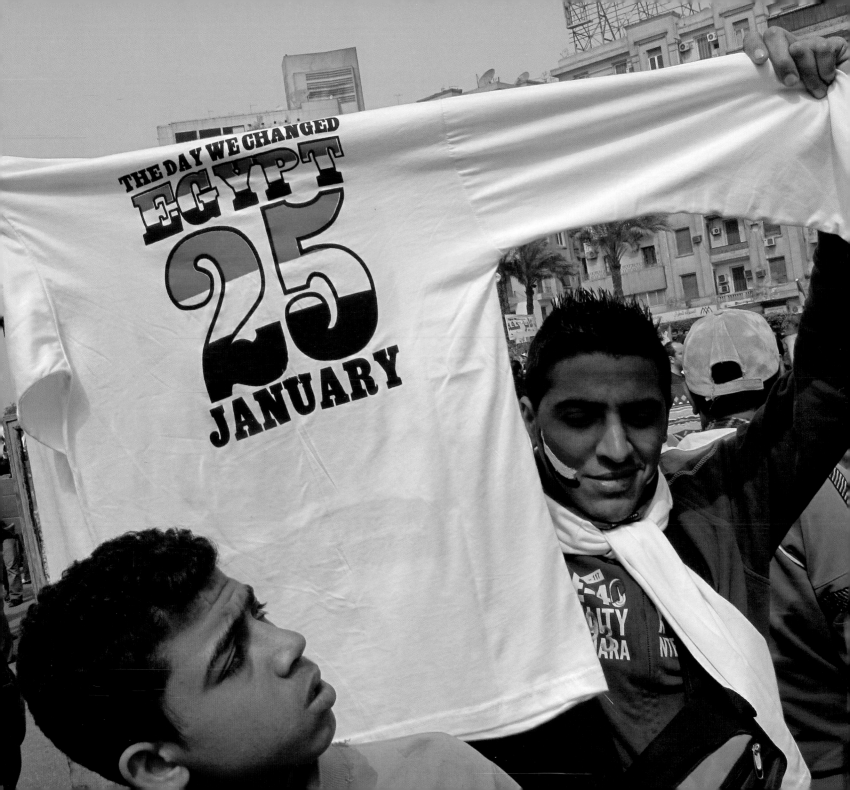

TAHRIR SQUARE

The Heart of the Egyptian Revolution

Photographs by
Mia Gröndahl

Foreword by
Ayman Mohyeldin

The American University in Cairo Press
Cairo New York

First published in 2011 by
The American University in Cairo Press
113 Sharia Kasr el Aini, Cairo, Egypt
420 Fifth Avenue, New York, NY 10018
www.aucpress.com

Dar el Kutub No. 4823/11
ISBN 978 977 416 511 5

Dar el Kutub Cataloging-in-Publication Data

Gröndahl, Mia
 Tahrir Square: The Heart of the Egyptian Revolution/ Mia Gröndahl. —
Cairo: The American University in Cairo Press, 2011
 p. cm.
 ISBN 978 977 416 511 5
 1. Egypt—History—1981 2. Revolution I. Title
 962.055

2 3 4 5 6 14 13 12

Designed by Andrea El-Akshar
Printed in Egypt

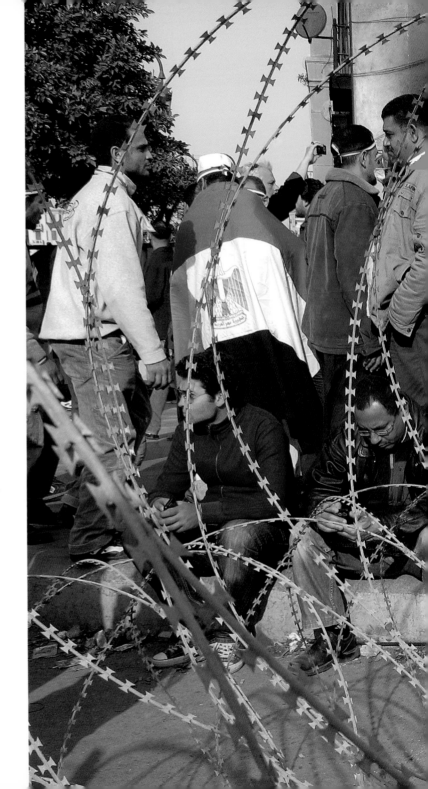

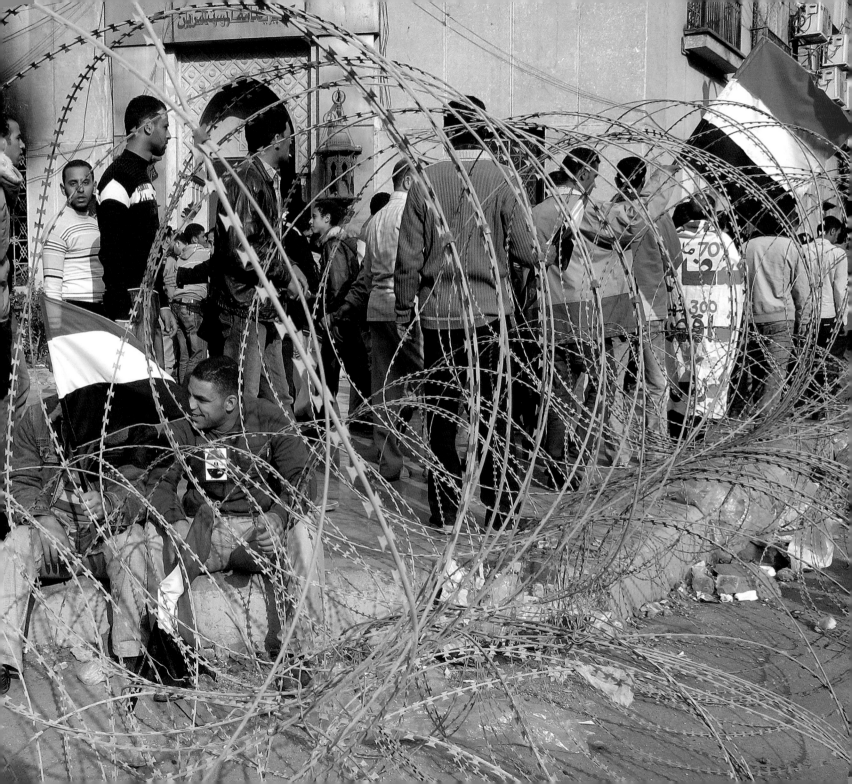

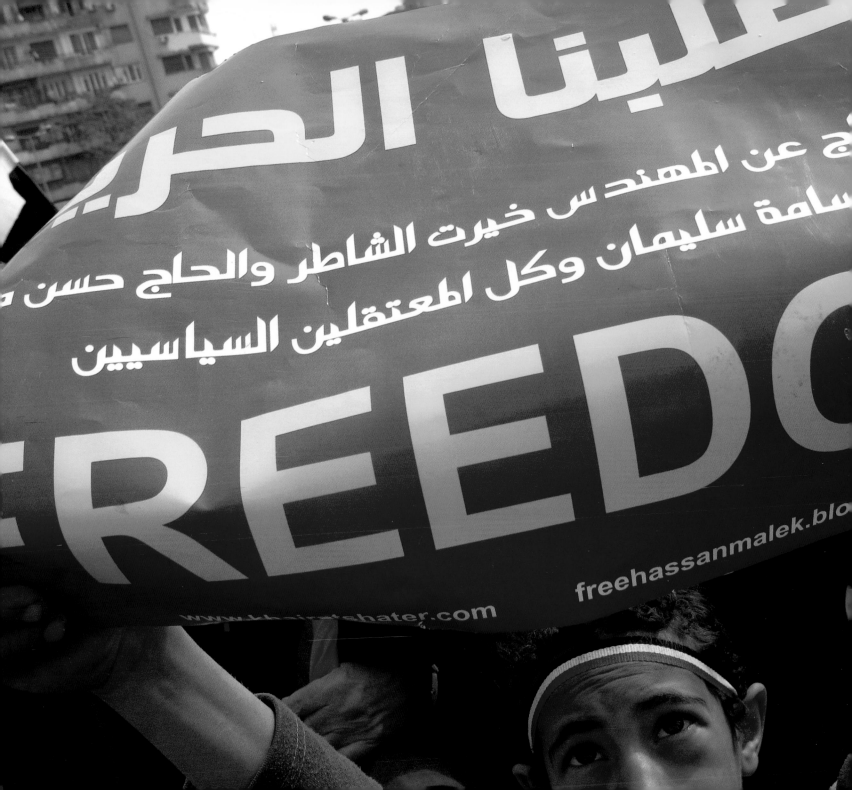

FOREWORD

Ayman Mohyeldin

In the heart of Cairo, in the shadow of some of the city's iconic buildings, five different roads pour into one hub. At the center of that intersection lies a simple, nondescript roundabout. Patchy grass and a few bushes are all that mark its center. Thousands of people and vehicles pass around it daily in a dizzying and often frustrating frenzy. There are no monuments, no memorials or plaques in sight. There are no benches for ordinary passersby to stop and catch a breath from the chaos of Cairo colliding around them.

For decades, this intersection and roundabout was nothing more than a traffic nightmare that bore the name Tahrir—perhaps even its meaning, 'Liberation,' lost on the millions of Egyptians who passed through it over the years. This Tahrir symbolized everything but liberation. It became the symbol of everything wrong in the country. It was known for its crowded traffic lanes lined by the country's despised police and notorious plain-clothes security agents. The towering Mugammaa, the Cairo city municipality building, the very symbol of bureaucracy and corruption that had become trademarks of the Egyptian regime, stood tall over Tahrir, and in the distant background a national museum bruised and battered by years of neglect not fitting of the historical treasures it housed. In the medley of gray and dirtied buildings rose the peach-gilded floors of one of Cairo's five-star casino hotels, a symbol of how the country's elite concealed the city's glaring realities from the cash-laden visitors who would flock to Egypt's tourist destinations while overlooking and ignoring its truth: Egypt was a country in decline.

But on 25 January 2011, Egypt gave birth to a new Tahrir, or Liberation, Square: one that finally lived up to its name—and one that ordinary Egyptians from all walks of life were proud of. This book tells the story of that new Tahrir and what it came to symbolize for Egyptians and the world through the power of pictures, not words.

As the Egypt correspondent for Al Jazeera English, I know firsthand the responsibility and challenges of accurately reporting the revolution in all its social, cultural, political, and economic dimensions. Along the way, we the journalists were simply in awe of what we witnessed. And as the son of an Egyptian who had emigrated to the United States, this assignment was personal. It made it that much more challenging, but it made me that much more determined to do the story justice.

I remember waking up on the morning of 28 January, the so-called 'Day of Anger,' and recording my will on my cell phone. If something happened to me, I wanted my family and friends to know what I was feeling that morning. I accompanied one of Egypt's leading opposition figures to Friday prayers in Giza. Shortly after prayers concluded, police began to attack the people who were simply exercising their right to free speech and assembly. The violence I saw that day told me Egypt would never be the same. I could see the determination in the eyes of everyone.

What unfolded that Friday and throughout the subsequent two weeks would change Egypt and indeed the Egyptian people forever. For the first time in my life, I saw a side of Egypt that all Egyptians had dreamed of but very few ever thought was possible. During Egypt's revolution, we saw the unity of the Egyptian people. We saw Muslims and Christians standing side by side, their voices equal in calls for regime change. We saw men and women respectfully standing shoulder to shoulder, each bearing their own responsibility in helping the revolution succeed. We saw the youth fueling the revolution with their optimism, while the elderly were reinvigorated by seeing the change that had eluded them for decades. Rich and poor, university professors and simple farmers—all stood as one, with one demand: change.

Never have I as a journalist experienced such a range of emotions on a single story: from fear and concern when the government began to crack down on Al Jazeera and whipped the country into a conspiratorial frenzy against journalists, to tears of joy when I saw the resilience of the Egyptian people in the wake of barbaric attacks by regime thugs against peaceful protests.

It didn't take long for the regime to realize what was at stake when these protests began. A few days into the events, Al Jazeera's offices were closed, our staff was detained, and our equipment was confiscated. The Egyptian government jammed our signal and interrupted our broadcasts, all with the intended aim of denying the world the right to know what was happening on the streets of Egypt.

The government wanted to control the message. It did not want the voice of ordinary Egyptians, which no longer quivered with fear, to ring out loud—just as the Egyptian people were determined to be heard and could no longer be silenced. We at Al Jazeera, both the English and the Arabic channels, were determined to carry the message that the people of Egypt would no longer be silenced.

As the crackdown and harassment of journalists intensified, we managed to sneak a camera and a small transmission

device into Tahrir Square. We realized, as did the protestors, that Tahrir would become the physical and symbolic epicenter of the Egyptian struggle. Where Tahrir went, so too would the revolution. The success of the revolution was going to be determined by the fate of this central Cairo intersection and the millions who gathered around it over the eighteen days from 25 January to 11 February, when the president finally stepped down.

Perched on top of a roof overlooking Tahrir Square, we fixed our camera on the people below—and every day throughout the revolution we showed the world the determination of the people of Egypt. Our camera became the microphone that amplified the calls of the protestors and, more importantly, a window into their struggle. Protestors felt comfort and protection knowing that our camera was recording history for the world to see. Despite attempts by the regime to paint the protestors as mischievous youth, foreign agents undermining Egypt's national security, and flat-out traitors, our cameras and coverage showed the world otherwise.

This book and these pictures are a continuation of that spirit. In these photographs you will see the true and real faces of the people behind Egypt's quest for a better future and freedom. You will see the people, equipped with nothing more than determination and belief, topple one of the most brutally equipped regimes in a matter of just eighteen days.

These pictures capture what was so plain for the world to see: the evolution of the revolution. They tell the story of the fall from power of one despotic ruler and his regime and the rise to power of eighty million people. This was the core driving force behind Egypt's revolution: the power of people trumping the people in power.

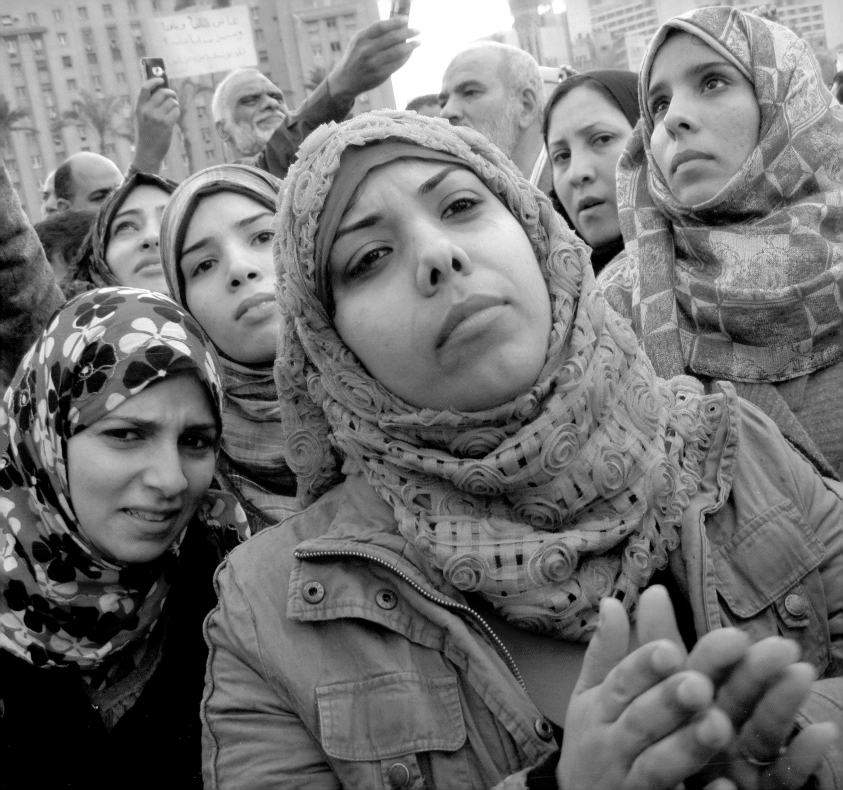

INTRODUCTION

I couldn't believe it. I arrived at Tahrir Square *without* my camera. It was taken at one of the many checkpoints I had to make my way through in Cairo's downtown area. The center of the city looked like a war zone after a week of clashes. Not all the checkpoints were friendly, and my pulse ran high. Some of them were governed by pro-Mubarak supporters who didn't want any foreigners, and especially not journalists, to meet with the protesters at Tahrir.

No camera. And here I was finally, eager to see with my own eyes an uprising that until then I had only been able to follow from a distance.

The Egyptian revolution had started while I was busy doing other things. The day before 25 January I was in Amman to open my photography exhibition Gaza Graffiti, and people asked if I thought a large number of people would join the call for protests in Egypt. "I'm afraid not," I said, and recalled earlier attempts to mobilize people, when tens of thousands had signed the protests on Facebook but only a handful showed up for the demonstrations.

I was totally wrong. Tuesday 25 January was to become the starting point for the Egyptian Revolution. I've been reporting from the Middle East for so many years, and still I didn't manage to read the writing on the wall. The fact that Cairo has been my base for ten years didn't help either. I should have listened more carefully to Mohammed, the young man I shared a cab with before I left Cairo for Amman. He was totally convinced that the time was ripe, and said: "Tunisia was first, now it's Egypt."

When I had recovered from the initial shock of having my working tool taken from me, I started to explore the square. I was surprised to find Tahrir such a welcoming place: it was like being res-

cued on a peaceful island in a frightening sea. From the media coverage of the first week's events at Tahrir, I was expecting more of a conflict scene in the stereotyped way we are used to seeing from the Middle East; a square filled with angry young Muslim men. Instead, I found myself in the middle of a well-organized festival of freedom, brimming with creativity and solidarity, and with people from all walks of life, young and old, Christian and Muslim, men and—lots of women.

Behind the protective barricades surrounding Tahrir, I was introduced to an Egypt I knew existed but never had seen so freely expressed, and by thousands of people at the same time. My heart swelled and I was swept away by the happy and hopeful atmosphere. Today I'm glad I didn't have a camera the first hours at the square; in a way I think I got closer to the general feeling at Tahrir; with a camera you tend to focus more on certain events and people you want to capture. In the end I was lucky to run into a friend and colleague, Cecilia Uddén from Swedish Radio. She offered me her small pocket camera and I was able to start taking the first pictures that eventually became this book.

I followed the people of Tahrir for twenty-one days, from 4 to 25 February. When I started documenting the square the Revolution had been going on for a week, the situation was still tense, the army had moved in and surrounded Tahrir Square with their tanks, but people were not ready to fully trust them; the previous two days of violent attacks by pro-Mubarak gangs had stained the square with the blood of many freedom seekers. But Friday 4 February, which was announced as the "Day of Departure," became a turning point. Huge crowds gathered again at Tahrir Square and all over Egypt, calling for President Mubarak to leave. The Square was injected with a renewed strength and hope, brought there by the increased numbers of whole families, men and women who came to Tahrir Square to fight for freedom and a better life together with their children.

When I moved around the square I realized to my amazement that the crowd was much more than a protest. I had never witnessed such a demonstration in all my life. The mass gathering at Tahrir Square was not just a rally, a whole community had sprouted up in the center of Cairo. Everything had its place at Tahrir Square. Beside the "tent city," where the protesters slept who protected the square during the nights, there was a field hospital, there were centers for information, for distributing food, tents and blankets, scribes ready to write slogans at your request, an art corner, slogan exhibits, a blogger's tent, an open-air place for reading newspapers, and even a kindergarten.

I looked around, almost in disbelief, asking myself "How is it possible?" So many people at the same place, almost standing on top of each other, and nobody is getting irritated, no sound of quarreling, no stress, no litter on the ground, everything in order and kept together by something I can only describe as a mutual sense of solidarity, equality, and—sheer happiness. Maybe it could also be described as a true vision of *democracy*. Democracy, a word that to most of us has been emptied of its real meaning. Tahrir Square—the heart of the Egyptian Revolution—reminded us all again what democracy is all about: to participate, to be an engaged and vital part of a society. Whoever we are and wherever we come from, oppressed or just comfortably tired and uninspired, the people of Tahrir not only showed us that it is possible to act, they showed the way to a better, more equal and happy future.

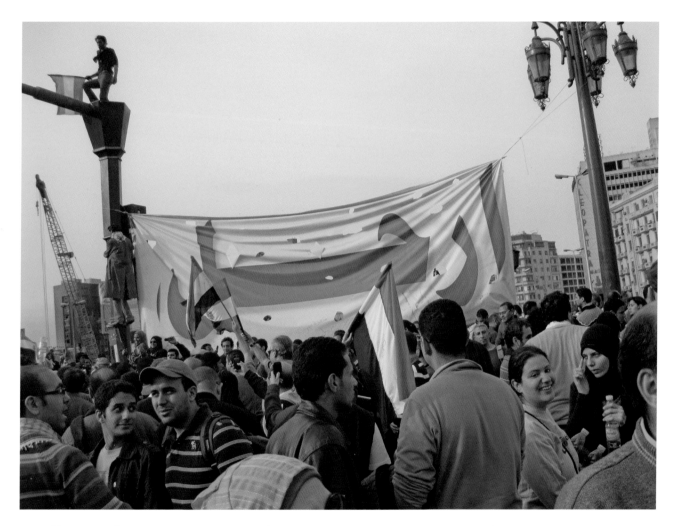

Tens of thousands of protesters attending the 'Day of Departure' rally in Tahrir Square, 4 February, to reinforce their demand for the resignation of President Hosni Mubarak. The banner says: *Irhal —Leave.*

I HAVE TAKEN PART IN DEMONSTRATIONS since the last century: against the king and British colonialism, against military rule after the defeat of 1967, against the policies of Sadat and Mubarak and American and Israeli colonialism—and I have never seen anything like this great people's revolution. My contact with Egypt's young men and women has not ceased over the years, so it was only natural for me to go with them every day to Tahrir Square. The revolution continues, in order to root out the old regime, to put them on trial, and to return the stolen millions. My childhood dream came true before my eyes, as barriers of gender, religion, and class melted away. I returned to my youth, riding home from Tahrir Square on a motorbike. I almost fell under the hooves of one of the horses that attacked us in the square. This has been a unique experience that will inspire my writing.

—**Nawal El Saadawi**, writer and women's rights activist

Righte: Tahrir Square on the 'Day of Departure.'

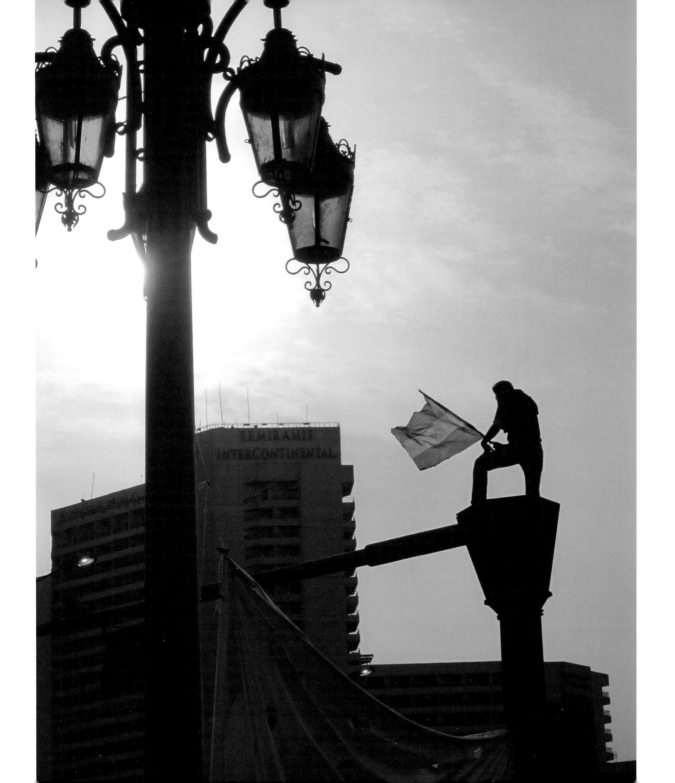

9

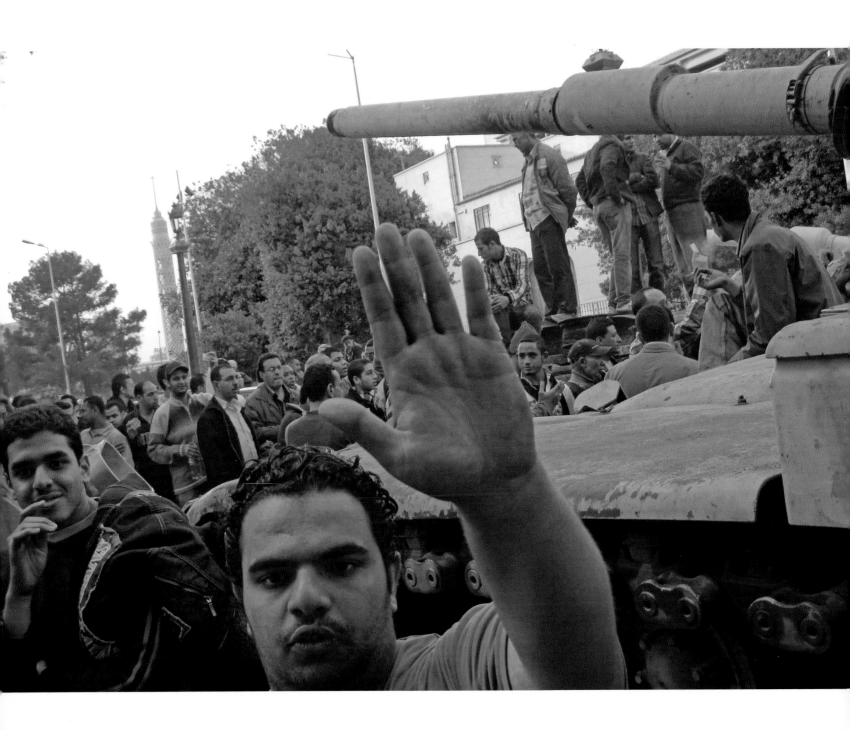

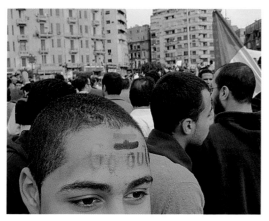 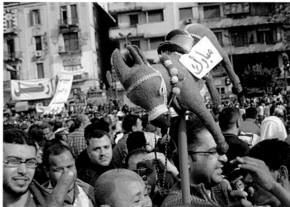 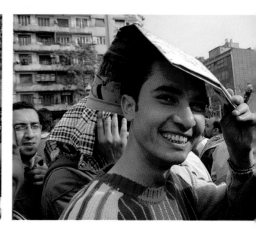

Above, left to right: Tahrir Square, 4 February.

The sign on the donkey says: *Mubarak.*

Free, free, I finally feel I am free, said this young man demonstrating for the removal of President Hosni Mubarak and his regime.

Left: When the army finally stepped in on 4 February, offering protection and keeping the thugs away, the tense situation in Tahrir cooled down. But the army was not yet ready to be caught on camera.

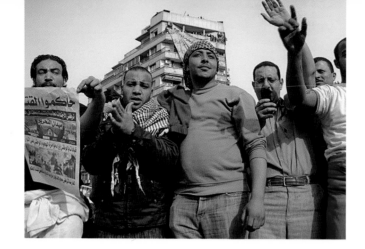

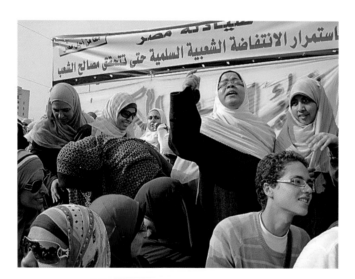

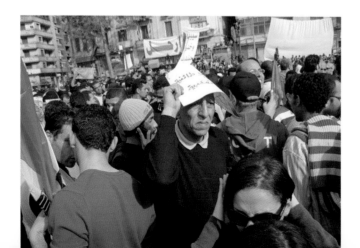

Top to bottom:
The 'Day of Departure,'
Tahrir Square.

Women protesters
gathered in front of
a banner saying:
*Pharmacists of Egypt
call for the continuation
of the popular uprising
until the people's
concerns are achieved.*

Tens of thousands of
people—including large
numbers of women
and children—gathered
in Tahrir Square on
Friday, February 4, for an
eleventh day of protest.

Right: Two giant lions
guard the end of Qasr
al-Nil Bridge, facing
the hustle and bustle
on the road leading to
Tahrir Square, just as they
have done since 1872.

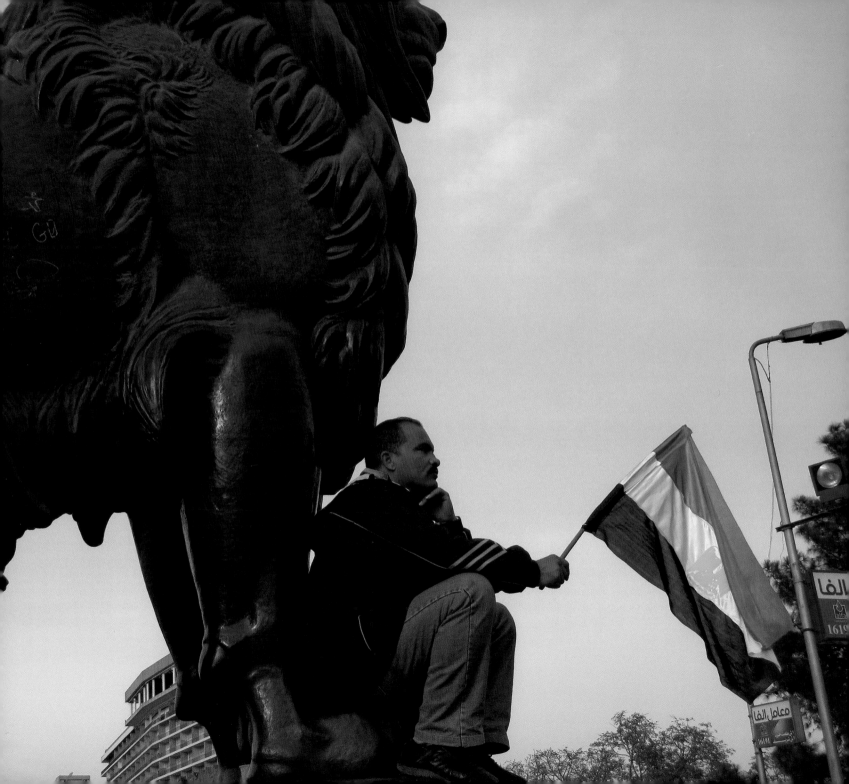

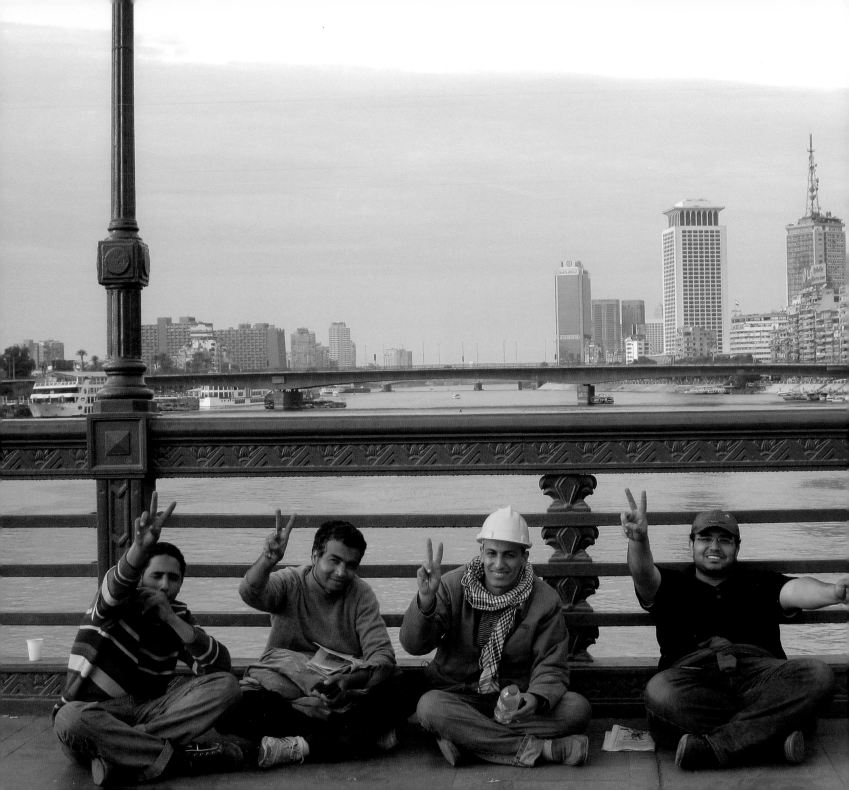

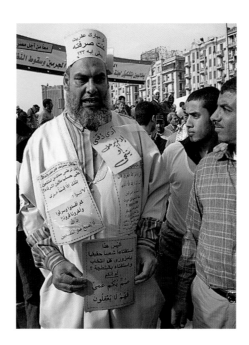

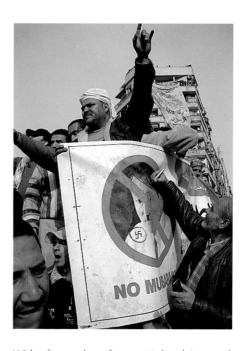

A man with many messages. On his hat the writing says: *If Mubarak was a ghost I would have driven him out—so what is he?* The sign attached to his beard reads: *Here's my beard if he doesn't leave or step down.*

With a few strokes of a pen, Mubarak is turned into Hitler.

Left: Anti-government protesters pausing on the Qasr al-Nil Bridge after a long day at Tahrir Square.

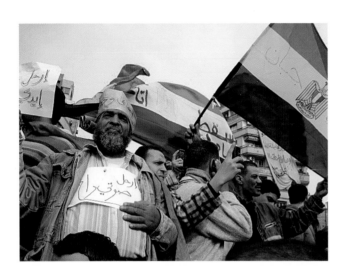

A living billboard with three reasons for Mubarak to leave. The sign on the man's hat reads: *Leave . . . my head hurts*. The piece on his chest says: *Leave . . . my voice is hoarse*. The sign in his hand says: *Leave . . . my arm aches*.

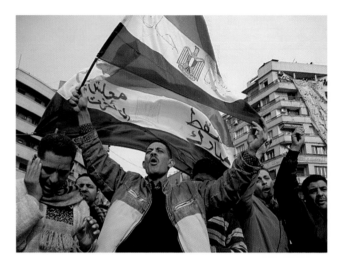

Leave! Leave! Leave! is heard from every corner of Tahrir Sqaure on 4 February, the 'Day of Departure.'

Right: After the street battle.

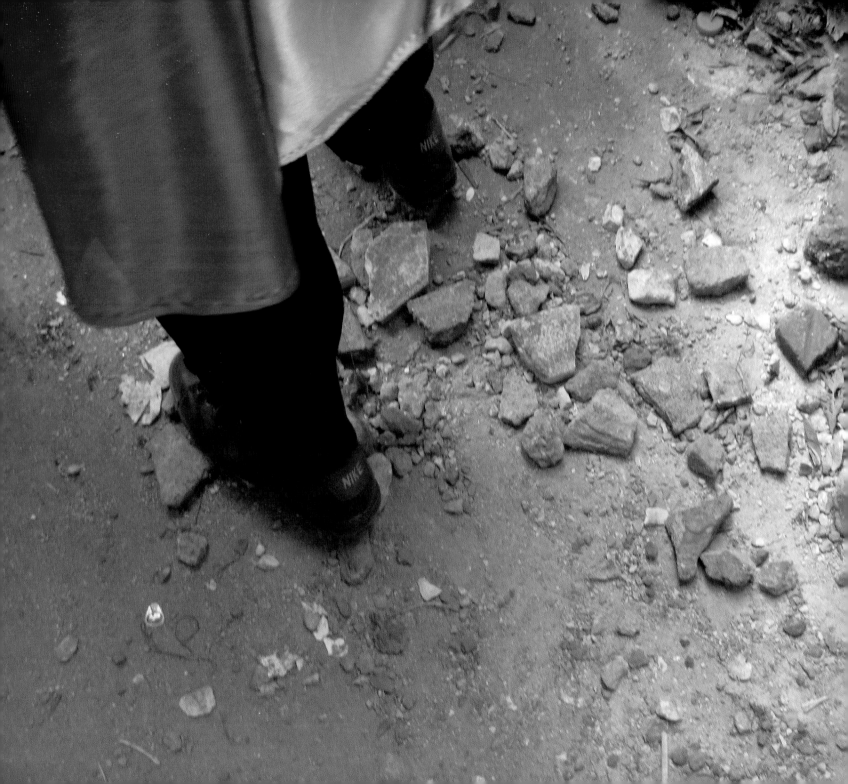

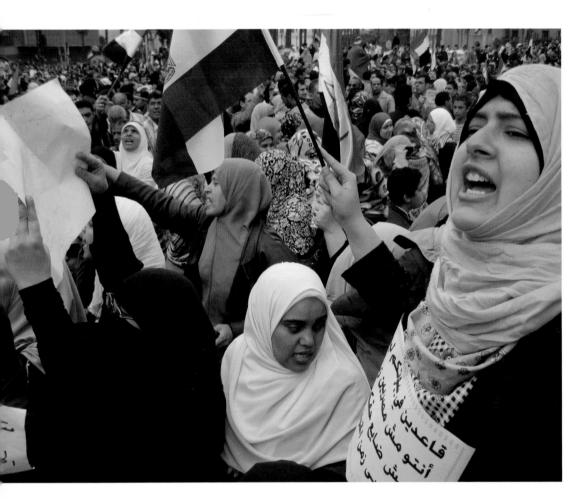

The yellow placard says: *Why are you staying at home? Aren't you Egyptians like us? Haven't you lost your rights? The time of fear has passed.*

Dina and Tawfik hurried back from abroad to join the Egyptian revolution.

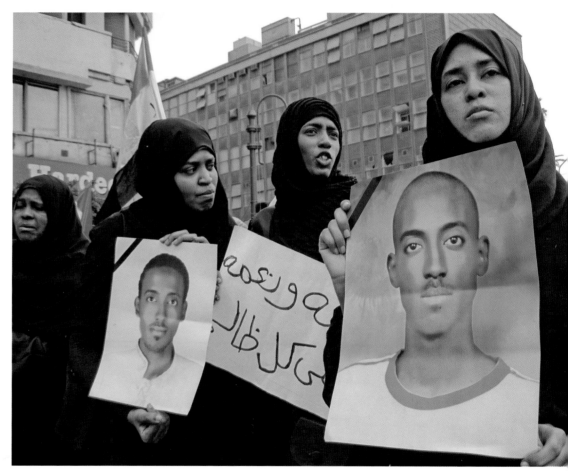

Ahmed Hilal was killed during the protests on 28 January. His sisters and mother Nawal joined Martyr's Day at Tahrir to honor their son and brother. The sign reads: *God protect us from every oppressor*.

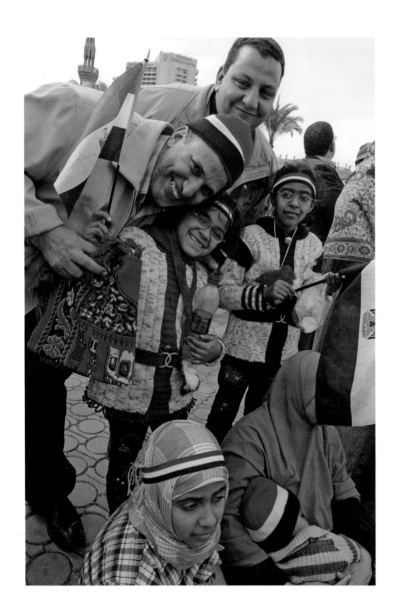

Left: Tahrir changed from being a battleground the first week of the revolution to a happy fairground where families could bring their children.

Right: Half the population of Egypt (52.3%) is under 25. The energy and spirit of the young moved the Egyptian revolution forward, step by step until the decisive Friday, February 11, when Mubarak resigned.

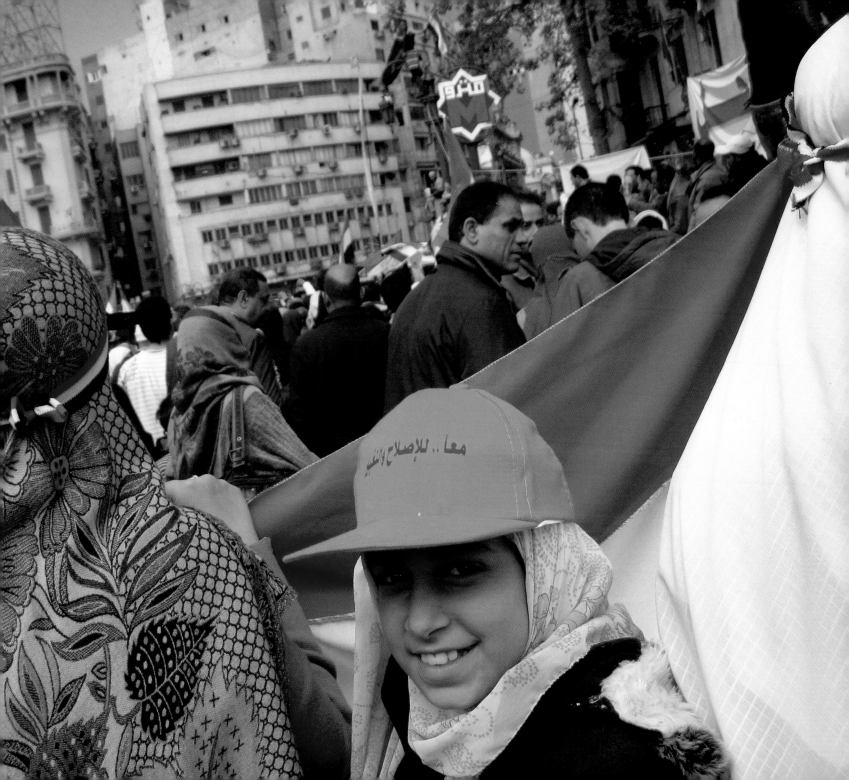

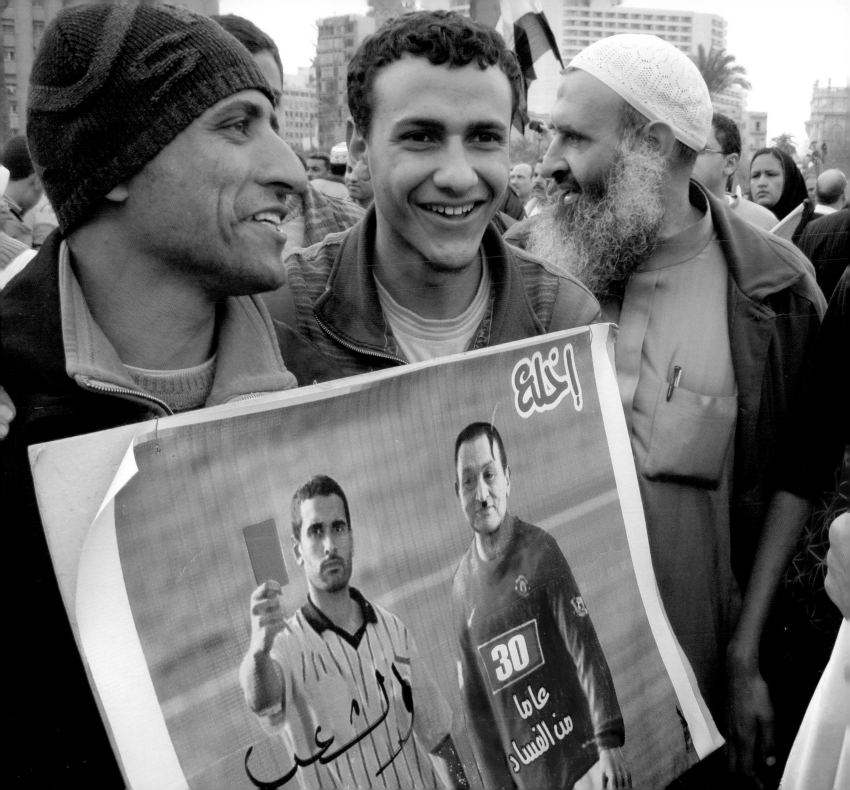

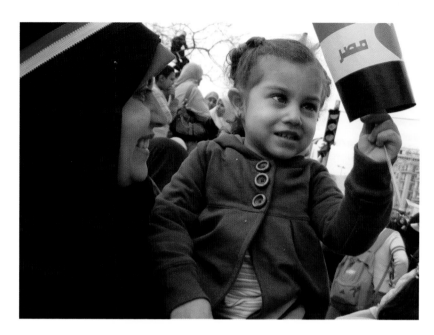

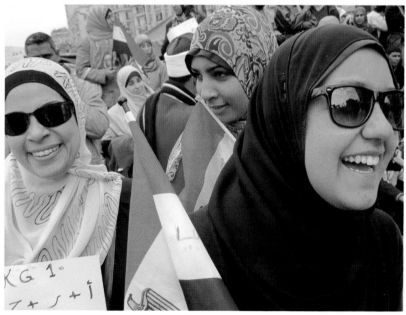

Top right: The little girl holds a
We All Love Egypt flag.

Bottom right: Friends ready for
change. The woman to the left
carries a sign that spells out the
main demand: *Kindergarten:
L+E+A+V+E.*

Left: The referee, who represents
the people, gives Mubarak the
red card. The writing on Mubarak
says: *30 years of corruption.*

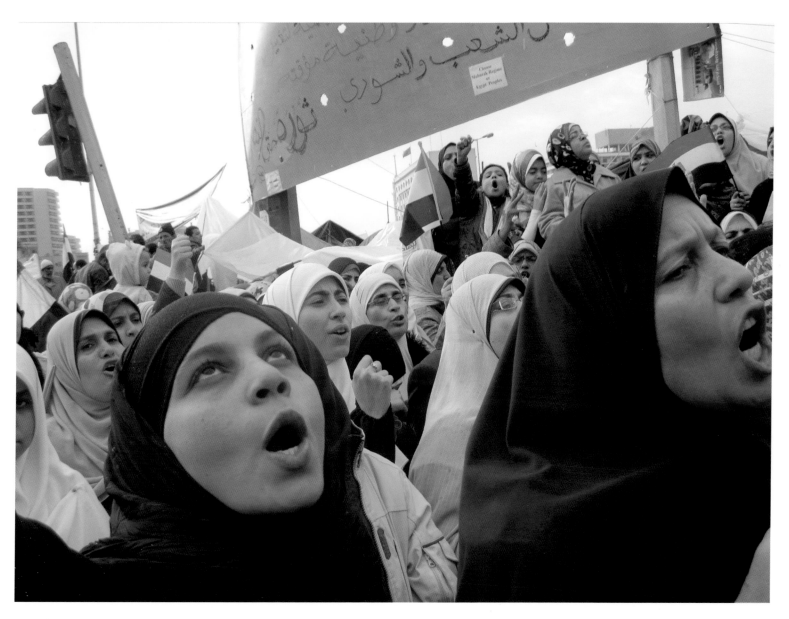

Many families came early to Tahrir, spent the whole day enjoying the happy mood at the square, and then left before the curfew started.

Tahrir hatta Tahrir (Tahrir until Liberation) was one of the most popular slogans.

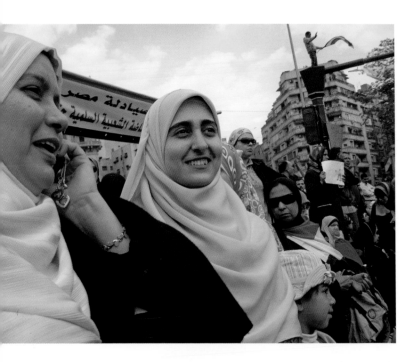

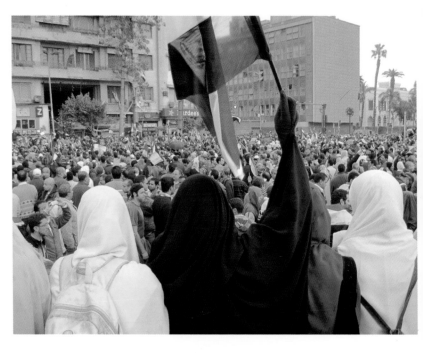

Women were as active as men at Tahrir. People were aware that something had changed in the dynamic between men and women. "Men's perception of us is more equal," said a young woman. "At Tahrir we were all Egyptians."

The main slogan of the Tahrir demonstrators was *al-Sha'b yuriid isqaat al-nizaam!*—The people want the fall of the regime!

Right: Thousands of women joined the demonstrators at Tahrir Square each day. They came on their own, with colleagues, friends, husbands, and children; teachers, university students, doctors and housewives; Muslims, with higab and without, and Christians.

Far right: Children were an integral part of Tahrir and everyone took care of them. The writing on the boy's forehead says: *Leave.*

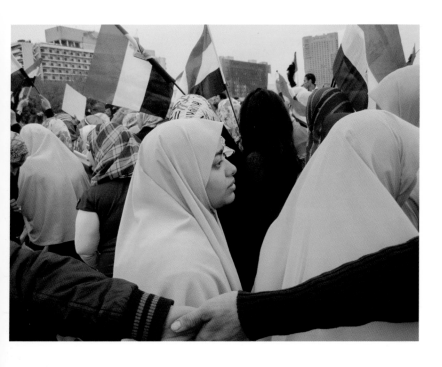

The protests calling for Mubarak's
removal unified men and women.

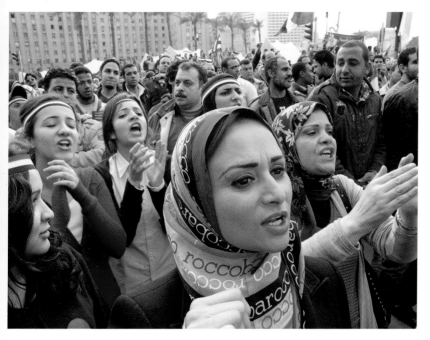

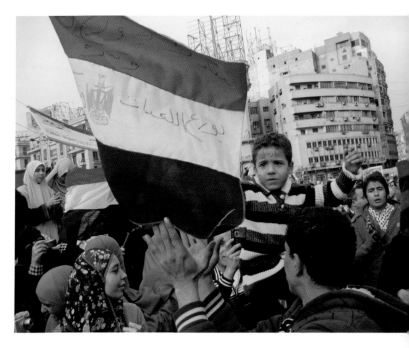

I ALWAYS FELT THEY STARED AT ME because I'm not veiled, maybe they even thought I was impolite. And to me they were extremists, closed-minded people who were hiding behind beards and veils. This was my relationship with the Muslim Brotherhood until 29 January.

On that day, I went to Tahrir dressed my usual way, wearing jeans and a short jacket. I ran down Qasr al-Aini Street, loudly repeating the slogans, feeling freedom and dignity.

I looked up and noticed a sign that read: "Down with Mubarak." I moved my eyes from the sign and saw that it was held up by a veiled woman. For the first time we were not looking at each other in the old way. Our eyes met, we smiled at each other and shared the victory sign.

—**Amira Abdul Rahman**, journalist

Over eighteen days in Tahrir Square, millions of Egyptian women protested alongside men.

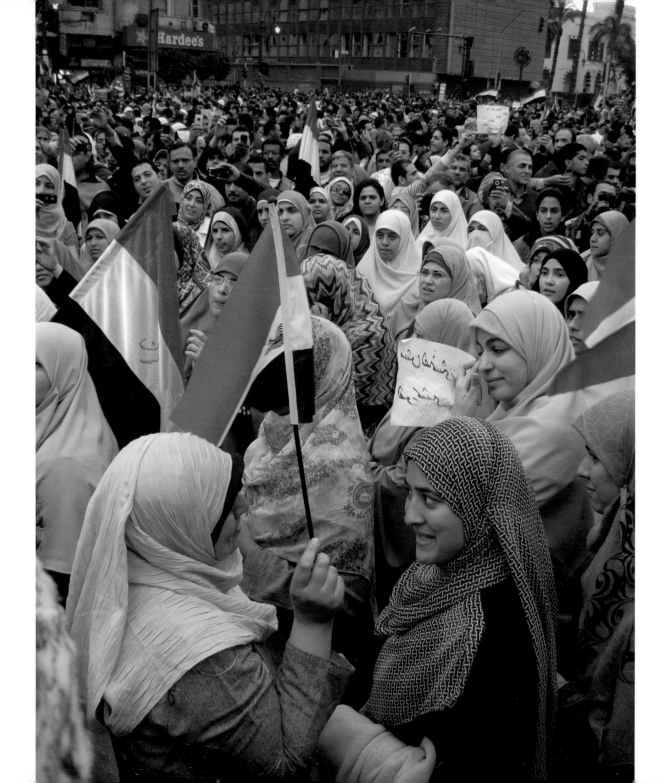

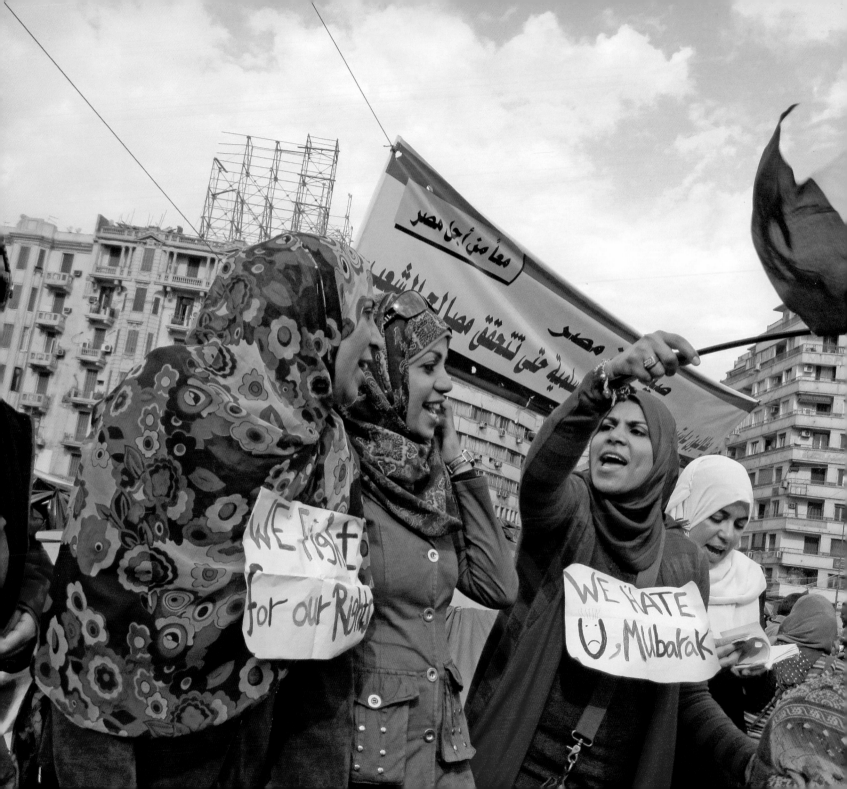

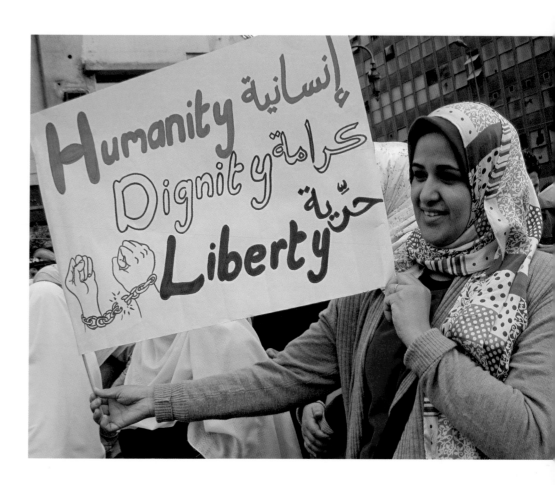

Women demand the removal
of the regime and equal rights.

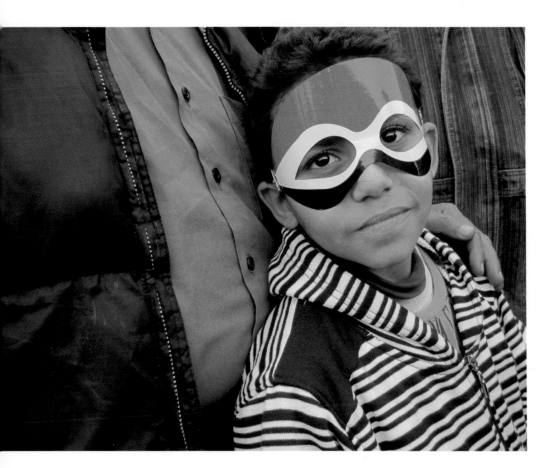

Above: Schools in Egypt were closed during the protests, so many brought their children to Tahrir, and a kindergarten was set up in the safest area of the square.

Right: Hoping for a better future. Almost 10 percent of those present in Tahrir were families. They added a special spirit to what people started calling the Republic of Tahrir.

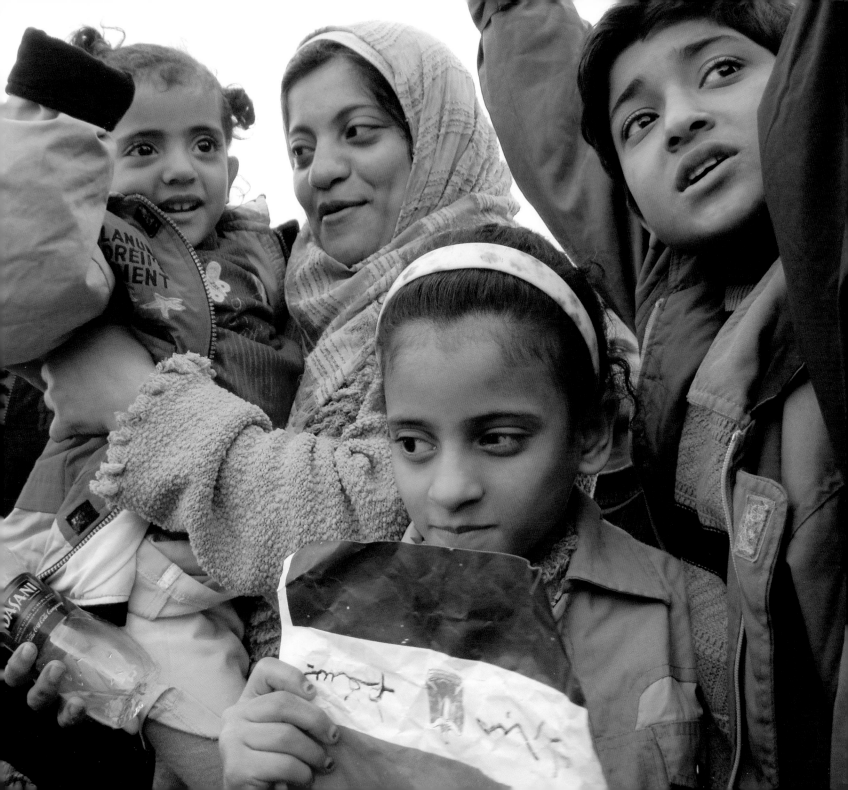

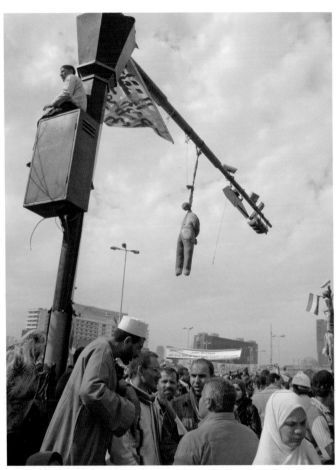

A Mubarak dummy hangs from a lamp post above
the anti-government demonstrators at Tahrir.

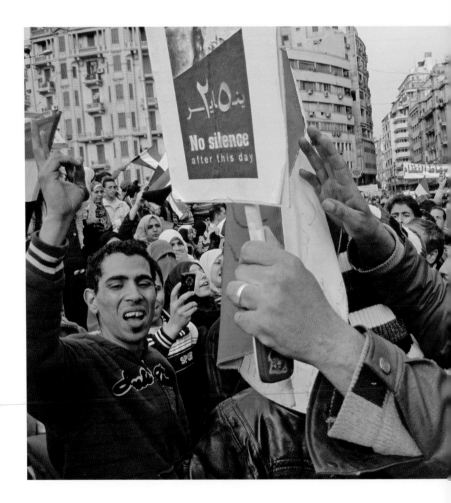

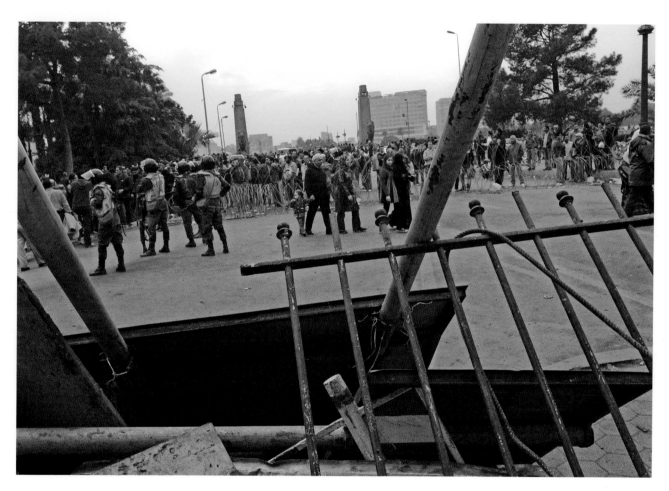

The army on guard between Qasr al-Nil
Bridge and the entrance to Tahrir Square.

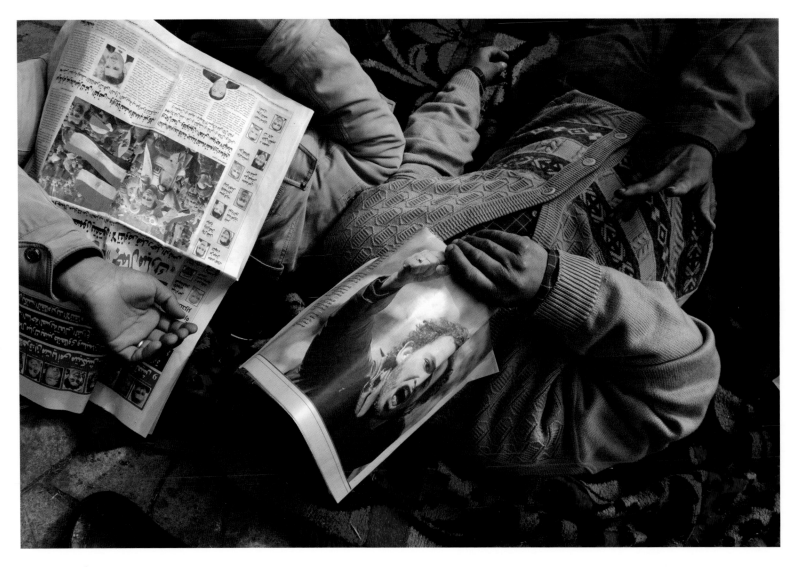

Morning at Tahrir.

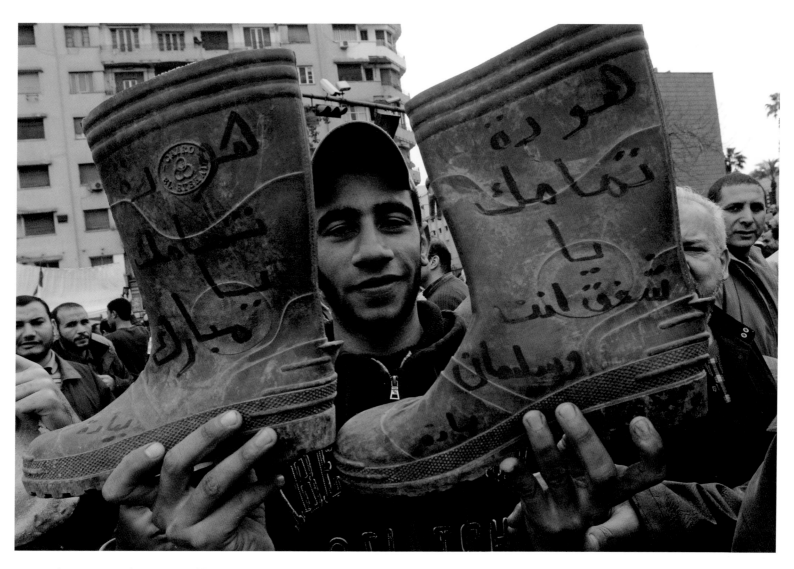

Boots with messages to the regime. Left boot: *This is your salute, Mubarak.* Right boot: *This is your salute, Shafik and Suleiman* (Prime Minister Ahmed Shafik and Vice President Omar Suleiman).

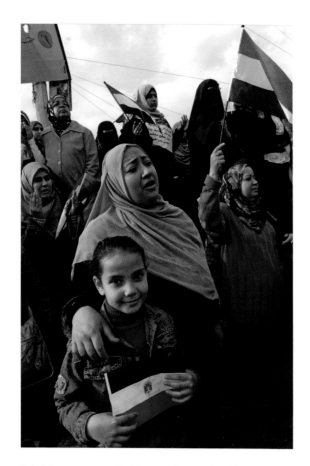

Tahrir became a symbol for standing up for what you believe in—for your rights—and not giving up.

Right: A new Egypt is born. *Leave* is written on the baby's bonnet and bib.

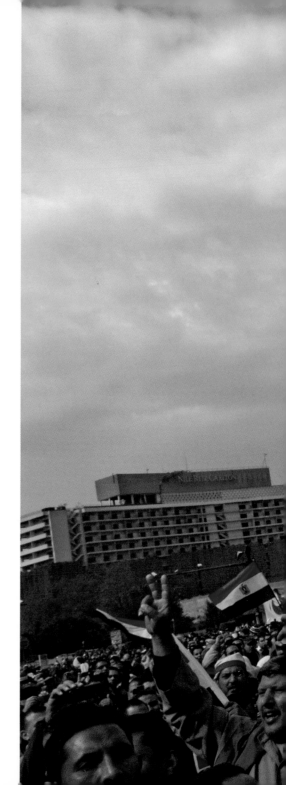

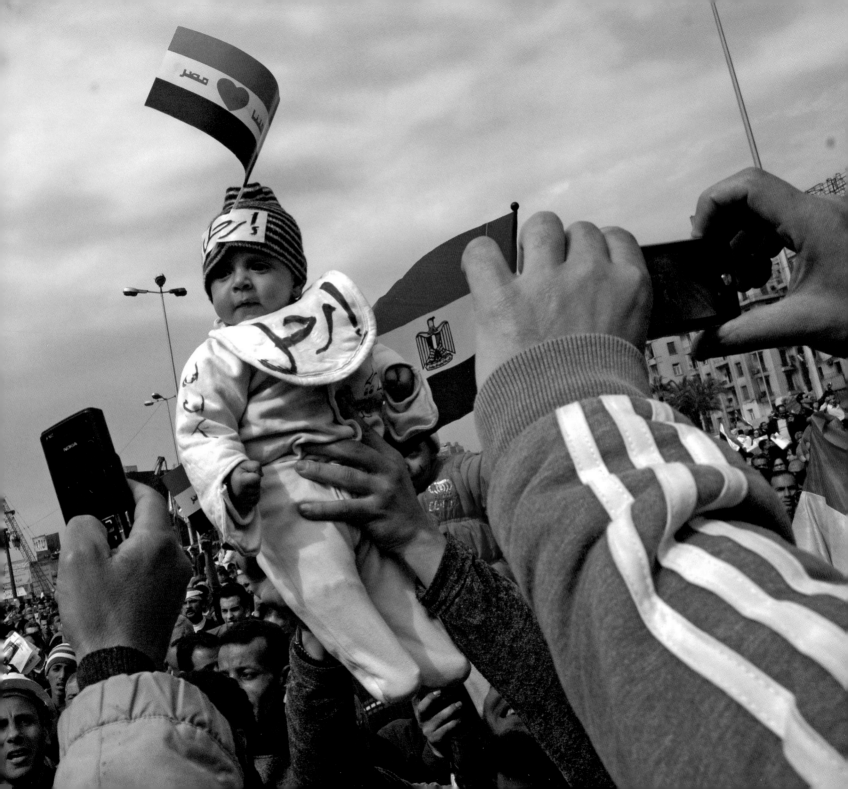

Women gather under a banner that lists the people's demands, including the formation of a new government and the dissolution of parliament.

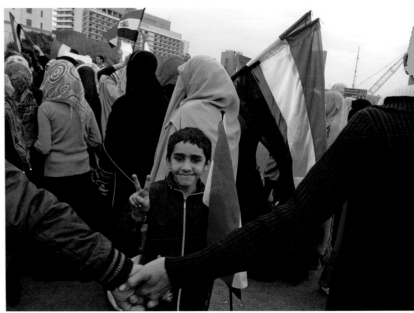

A boy makes the victory sign on Martyrs Day, 6 February.

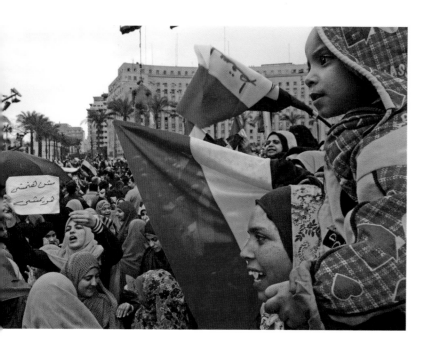

Female demonstrators chant slogans and hold signs that say:
We won't go, he must go (he: President Hosni Mubarak).

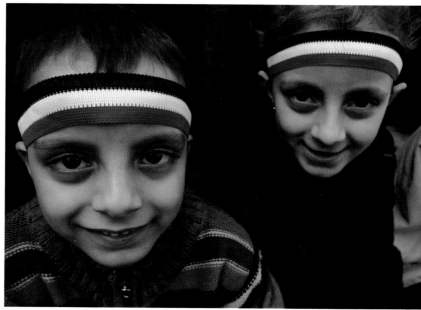

Brother and sister at Tahrir Square
on Martyrs Day, 6 February.

I HAVE BEEN GOING AND COMING through Tahrir Square on a daily basis for ten years. I used to wonder what had happened to Egyptians. People from different social classes passed by the square with one thing in common: a broken look in their eyes, whether they were rich or poor, educated or illiterate. I used to contemplate what the future might hold for all of us. Not in my wildest dreams could I have imagined that the same square would usher in a new era on 25 January, a revolution that would go down in history as a success story of people's determination to take their destiny into their own hands. The Tahrir revolution led to the revival of Egypt's soul and pride. Tahrir square will always be remembered as the place where Egyptians chanted with bright eyes: "Hold your head up high: Be proud, you are an Egyptian." That is more than a slogan; that is the route to build Egypt's future.

—**Amr Moussa**, former foreign minister of Egypt

Proud to be Egyptian.

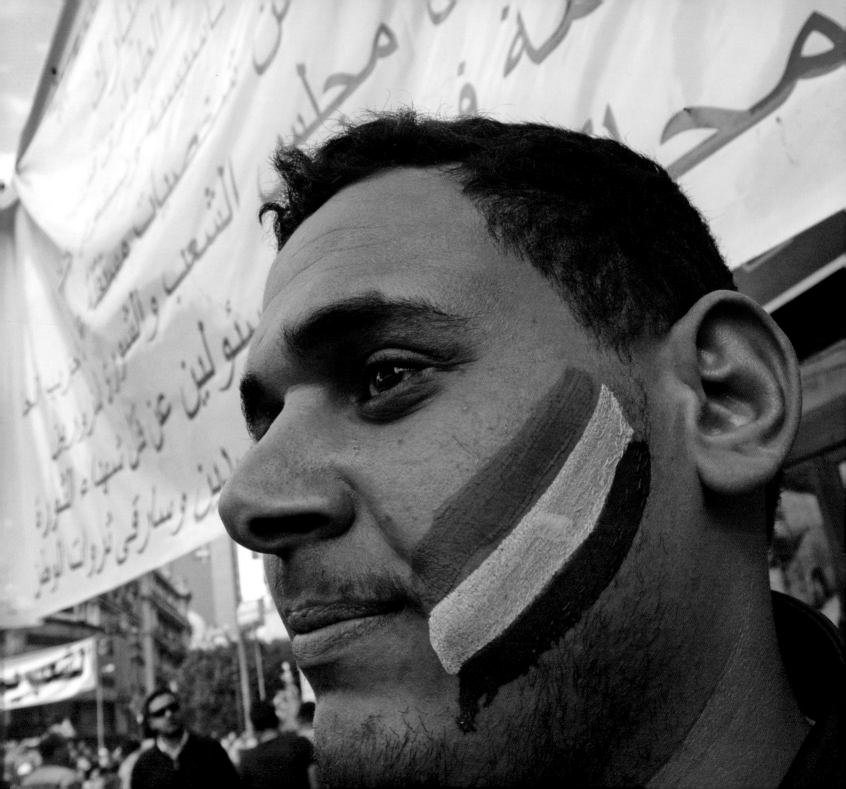

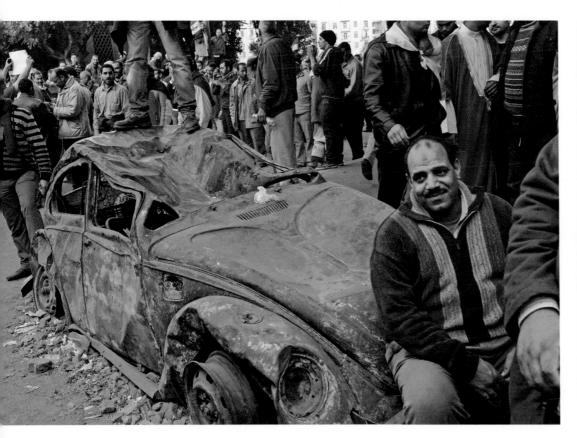

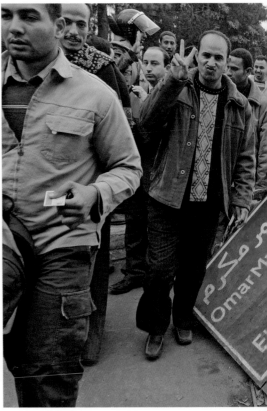

Anti-government protesters at a burned-out vehicle destroyed during the clashes at the entrance to Tahrir Square from Qasr al-Nil Bridge.

A barricade at the entrance leading from Qasr al-Nil Bridge to Tahrir Square.

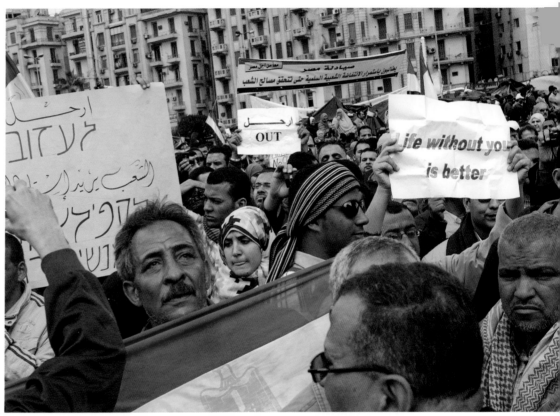

Among the crowd of protesters, a man carries the Egyptian flag. The pink placard behind him is written in both Arabic *(Leave)* and Hebrew *(Stop the killing)*. Hebrew was used, explained a protester, "because Mubarak doesn't seem to understand what we demand in Arabic."

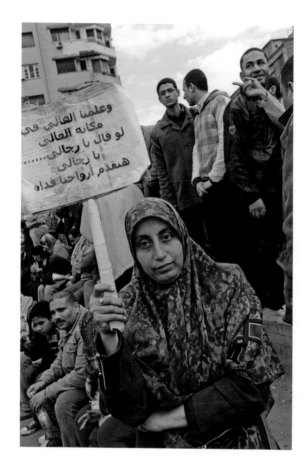

A woman holds a sign that reads: *Our precious flag is flying high; if it calls on us, we will offer our souls for its sake.*

Right: A man dressed in the Egyptian flag holds up a banner that says: *Egypt is speaking for herself; We love you, Egypt.*

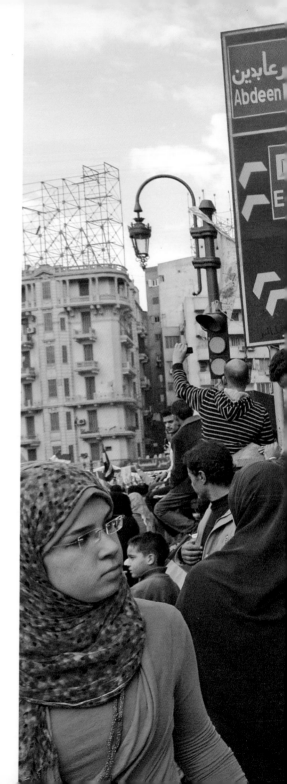

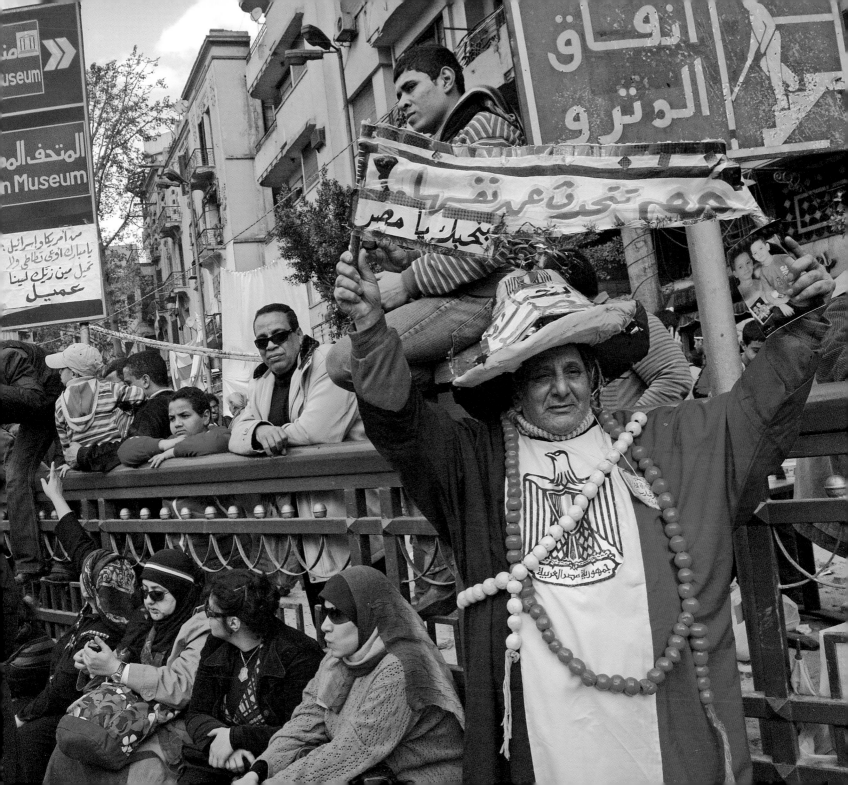

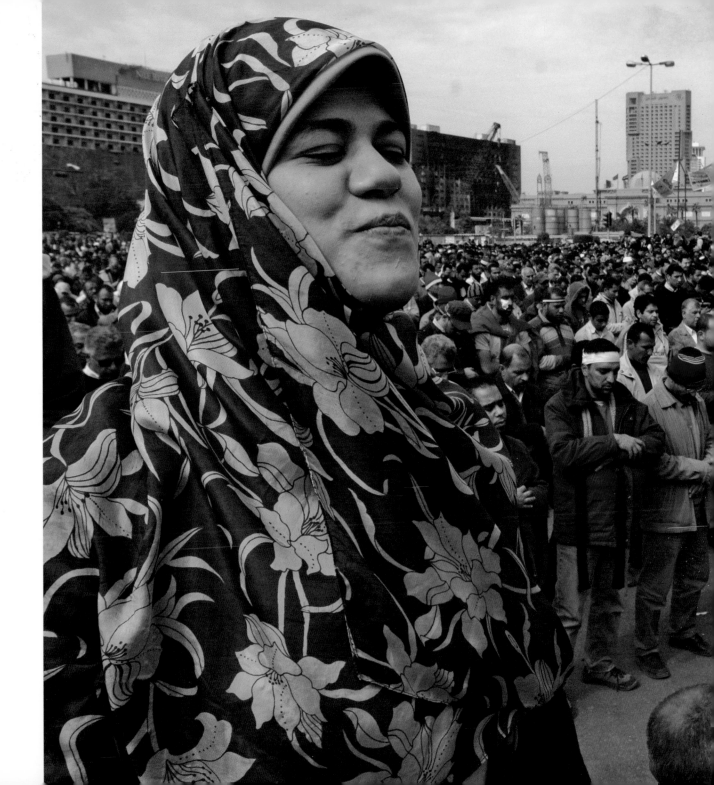

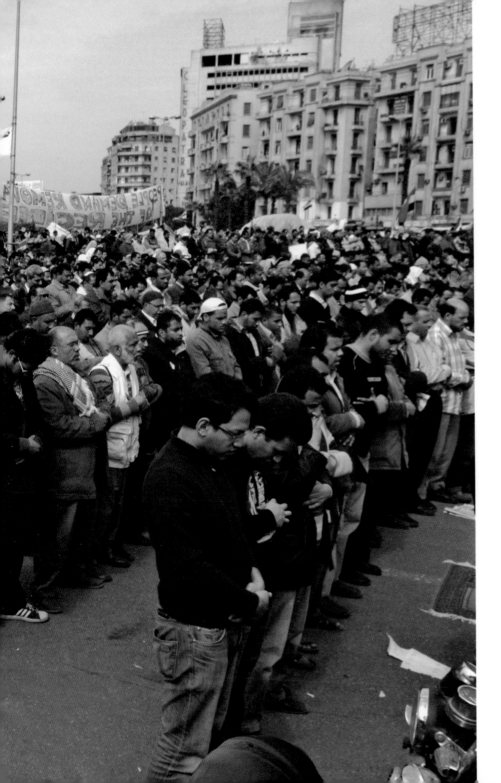

On Martyrs Day, 6 February,
Christians and Muslims prayed
together. The orange building at
the back is the Egyptian Museum.

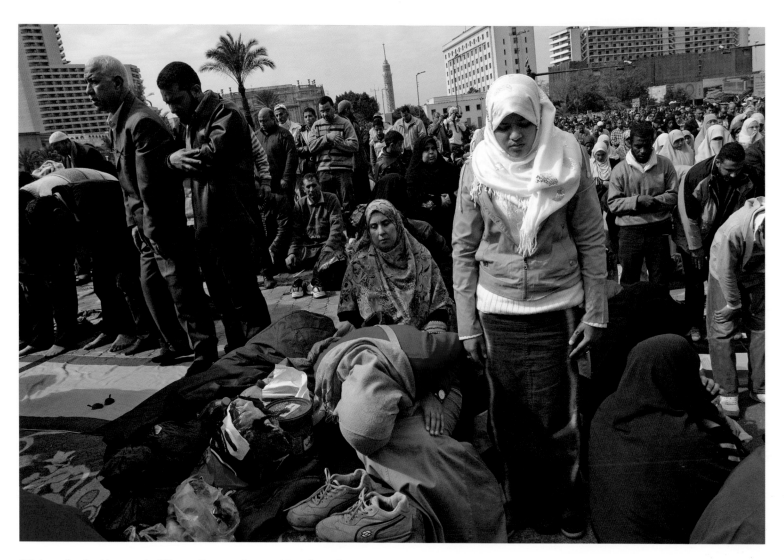

"We are all united here and will be until our goals are achieved, Muslims and Christians," said one Christian protester who joined Christian and Muslim mass prayers on Sunday 6 February.

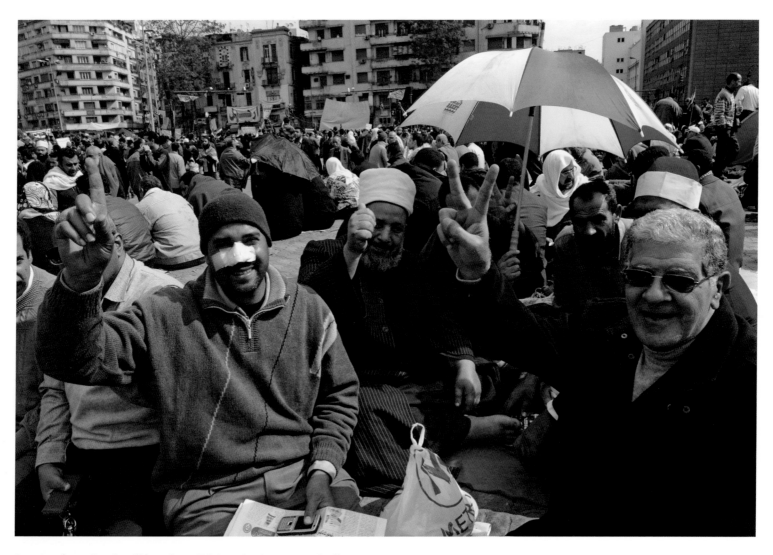

Egyptians from all walks of life gather at Tahrir under the same umbrella.

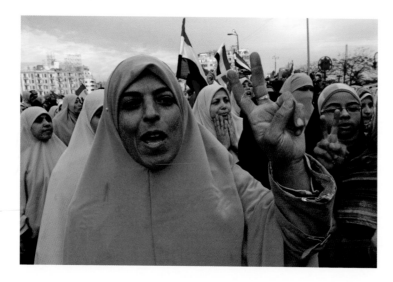

For the first time in a long time, Egyptians found their voice—and were not afraid to use it.

Right: On 6 February, the fourteenth day of protests, demonstrators called for the removal of President Hosni Mubarak.

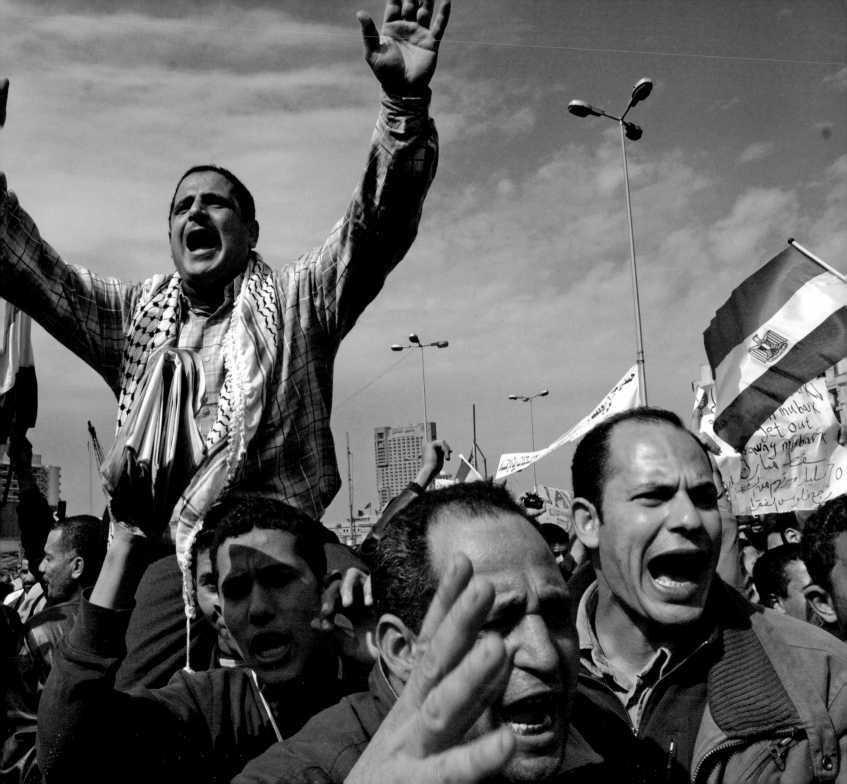

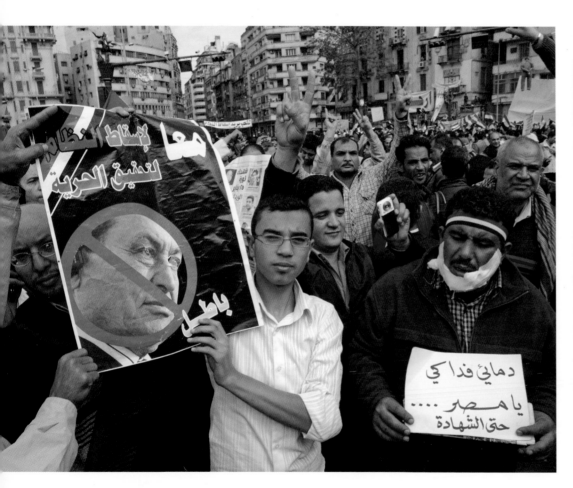

The poster with a crossed-out Mubarak says: *Together for the fall of the regime, for the realization of liberty.* The bandaged man to the right holds a sign that reads: *My blood for your sake, Egypt, even martyrdom.*

People pour into Tahrir Square from Qasr al-Nil Bridge to join the protests.

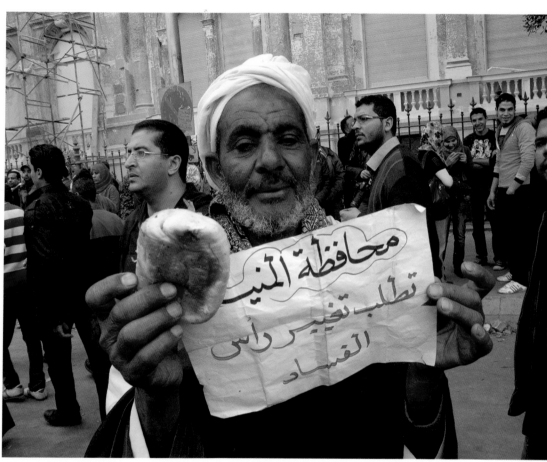

By holding up a simple piece of bread, the man wants to show that the demonstrators at Tahrir are not eating Kentucky Fried Chicken, as Egypt's State Media falsely announced. The sign says: *Minya Governorate demands the change of the head of corruption.*

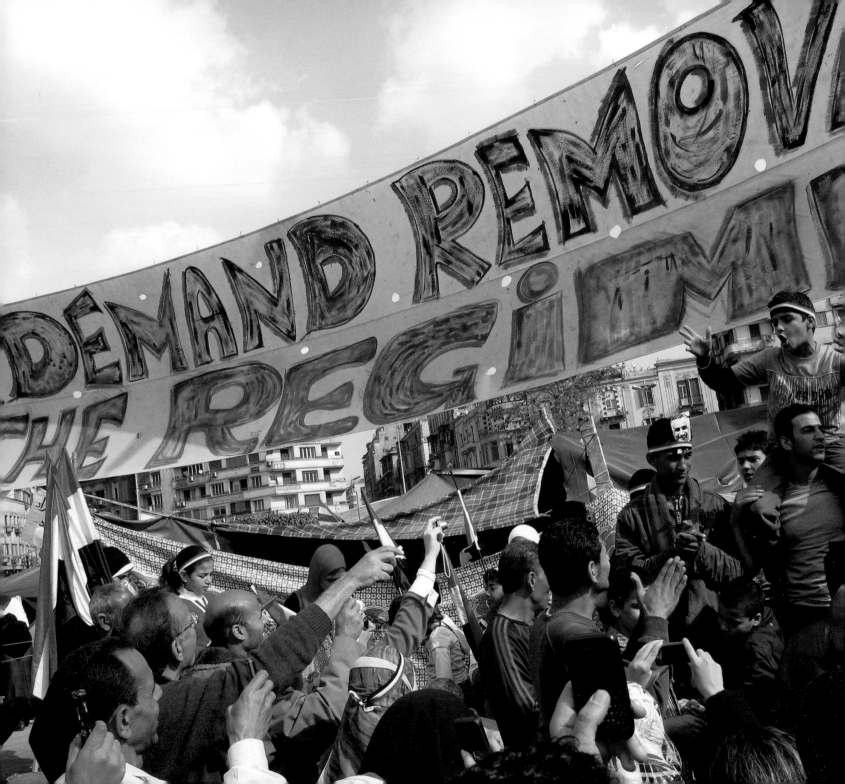

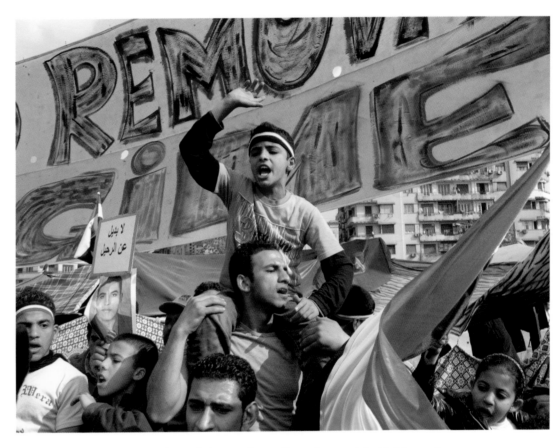

A young boy leads the chant in front of a banner that spells out the people's chief demand. He interrupts his rap-like chant to ask: *How many colors has our flag?* When the audience replies *Three colors!* he continues: *Red is the blood of the people. White is the pure heart of the people. Black is the anger of the people.*

I CAME TO TAHRIR to defend the people. There is nothing more important in life than freedom. My mother was very worried when I left Damietta, but she supported me and said: "If you die at Tahrir, you will die for something you believe in." It was an amazing moment when I arrived in the square. People I'd never met before were hugging and welcoming me like a brother. I didn't know we were so many people who wanted the same thing: to think, live, and pray freely. It's an incredible feeling knowing that you are not alone any more.

—**Hazem Monir**, businessman

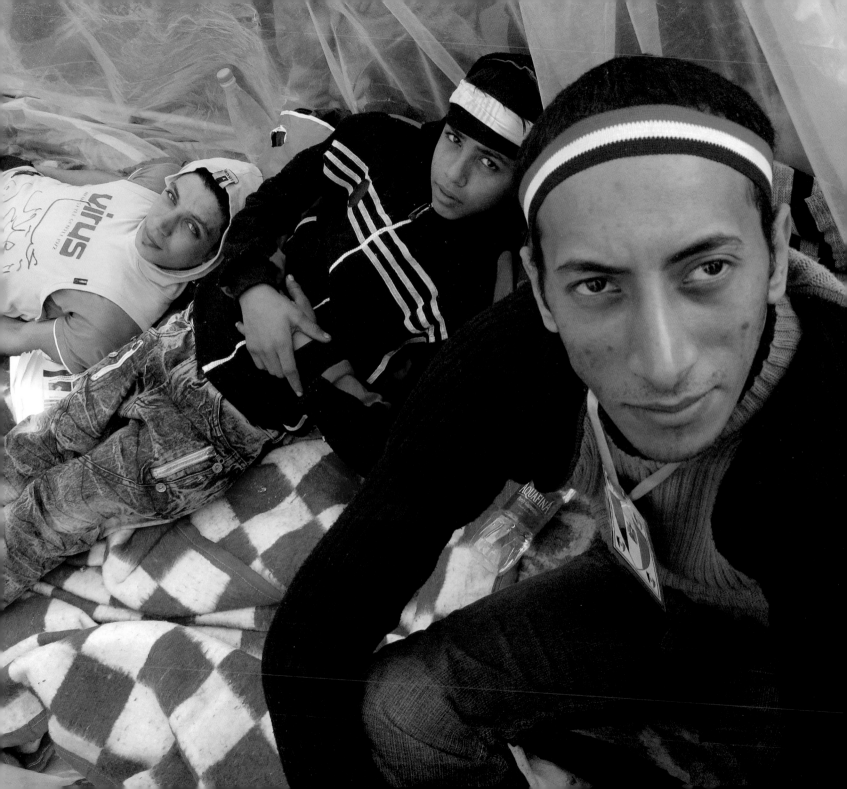

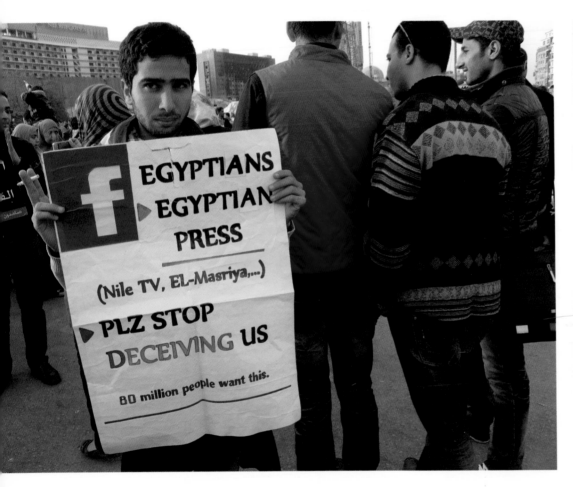

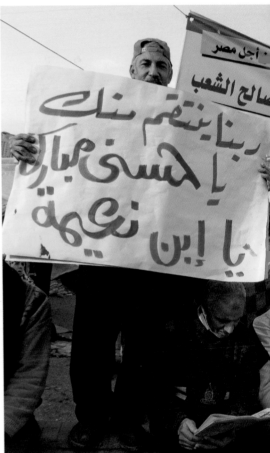

Up until the resignation of Mubarak the regime and its state media slandered those inside the square as western puppets fueled by fistfuls of euros and American fast food.

The blue sign reads: *May God take his revenge on you, Hosni Mubarak, son of Naima.* In Arabic culture it's an insult to be named after your mother.

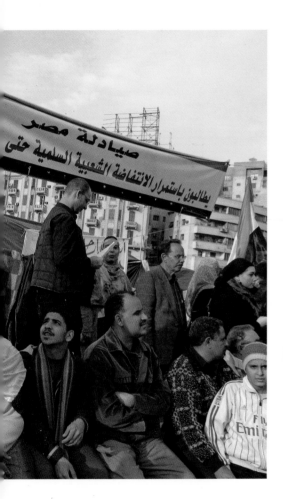

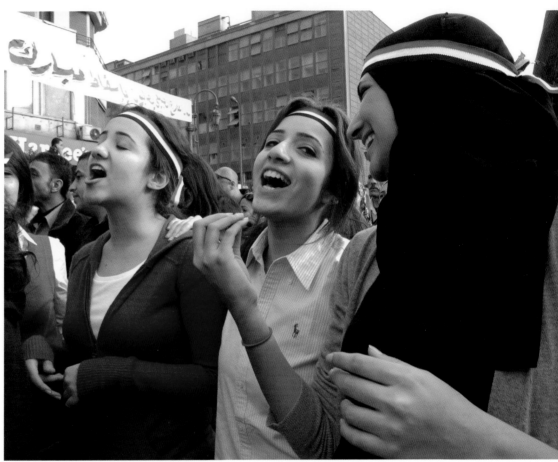

Women were at the heart of the Tahrir movement,
dressed in hijab as well as blue jeans.

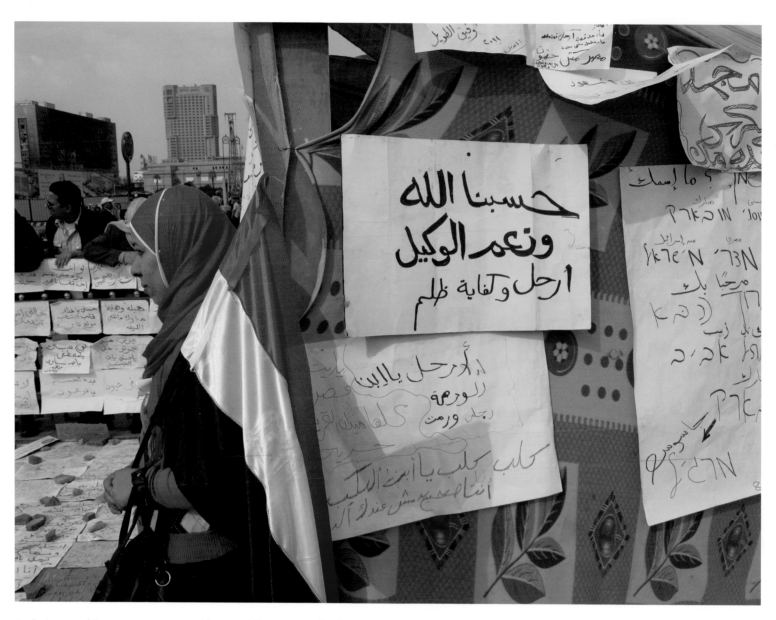

A whole area of the square was reserved for people's messages. The slogans covered a long fence on both sides, the asphalt, and the walls of a shed. The main sign in the center reads: *God is our protector. Leave, enough oppression!*

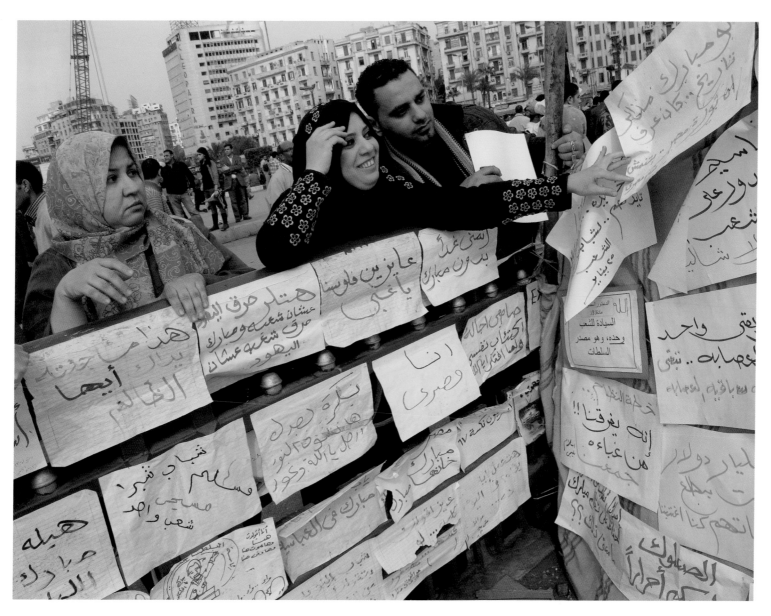

The woman is reading a sign that says: *If Mubarak had studied history, he would have known that the revolution of Egypt does not sleep. Signature: An Egyptian youth.*

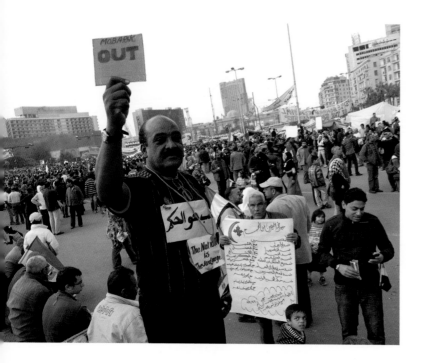

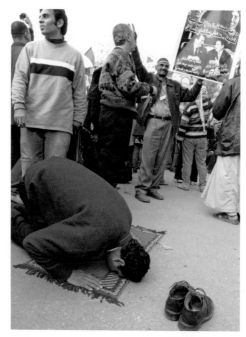

Left to right:
Game over, Mubarak. The yellow sign on chest of the man says: *The people are the referee*. Behind the man's head is the burned-out shell of the National Democratic Party headquarters.

An Egyptian anti-government demonstrator prays at Tahrir Square, 9 February.

Two dictators having a conversation while the people are suffering. The writing at the top says: *We haven't made 70 billion yet. Damn it, it's not easy to make a living.* Tunisia's Ben Ali turns to Mubarak: *Damn you, I didn't know you were so crafty. You're really something, what a master!* Mubarak is not ready to return the pleasantries, and tells Ben Ali: *You're a disgrace. See how it's done? You turned out to be a real wimp: you gave in too quickly and let us down.*

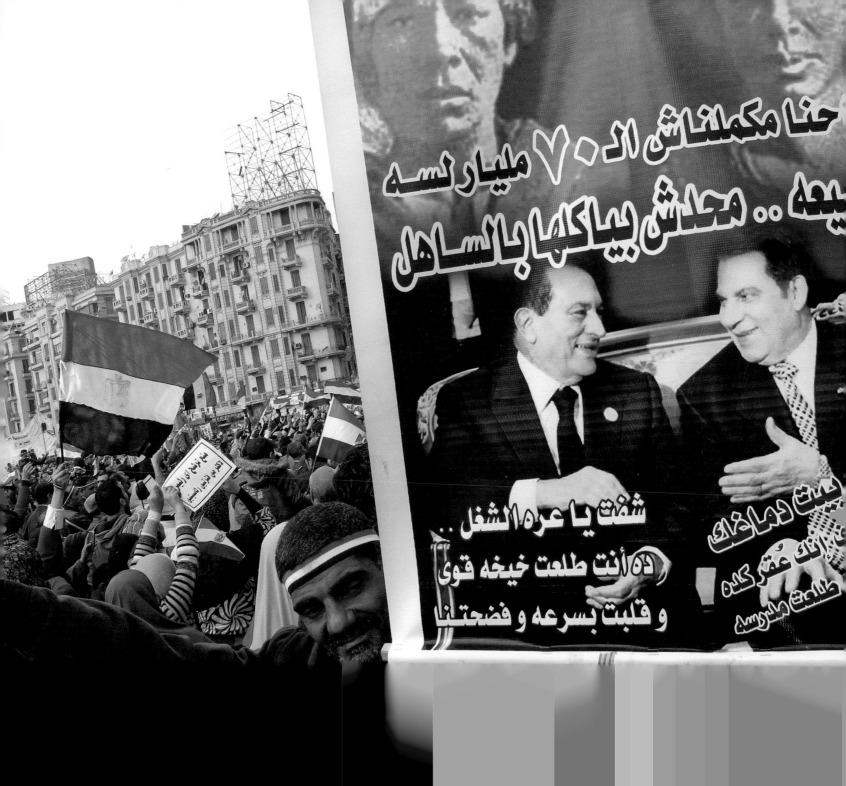

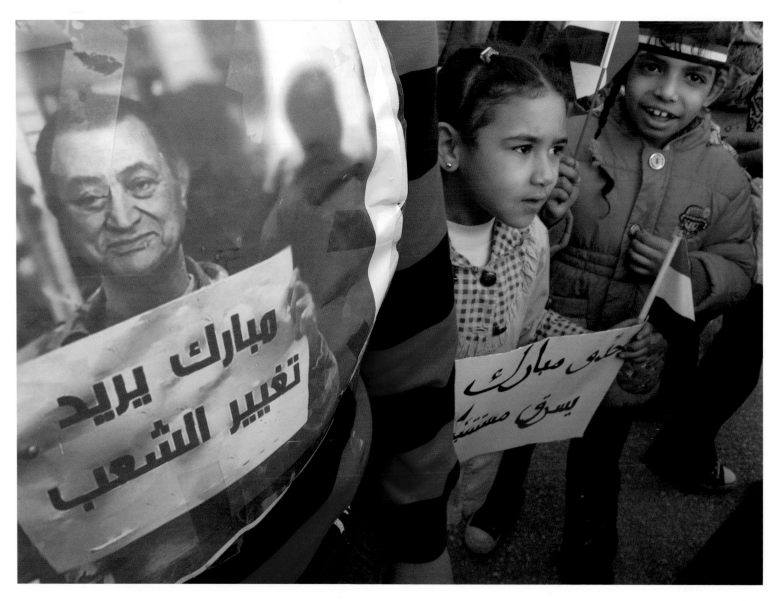

The girl holds a sign saying: *Grandpa Mubarak is stealing our future*.
Mubarak's reads: *Mubarak wants a change of people*.

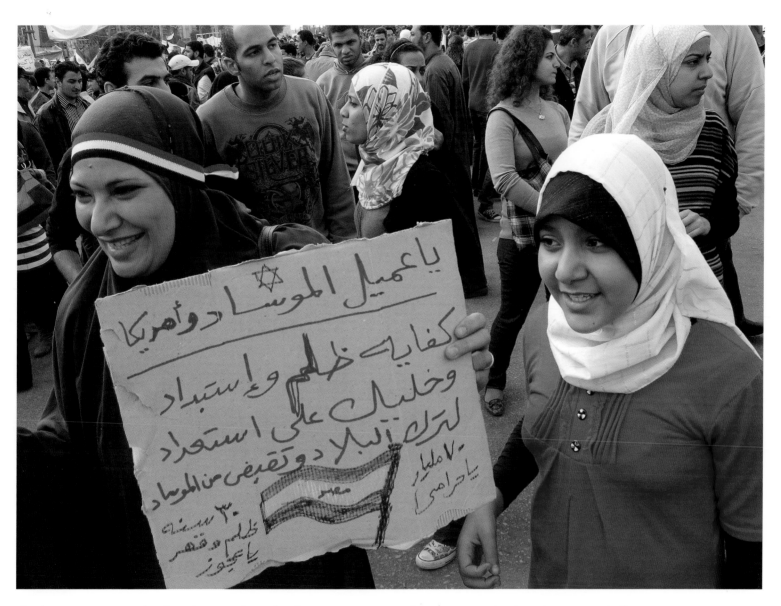

The rhyming message on the placard is meant for Mubarak: *Agent of Mossad and America! Kifaya zulm wa istabdad; wa khallik 'ala ista'dad; li-tark al-bilad; wa tuqbud min al-Musad. —Enough oppression and autocracy. Be ready to leave the country and collect your pay from Mossad.* And at the bottom: *70 billion, you thief! 30 years of oppression and subjugation, old man!*

FIRST OF ALL: SHAME ON ME! I thought 25 January would only gather a hundred or at most a few hundred people, so I didn't participate as I've done at previous protests. But after I saw the masses at Tahrir and how the police treated them, I hurried to the square.

At Tahrir I saw the Egyptian people act in a civil way no one could have imagined, and they came from all levels of society. I want to thank the youth of Egypt. You brought my soul back.

—**Yasser Rostom**, artist

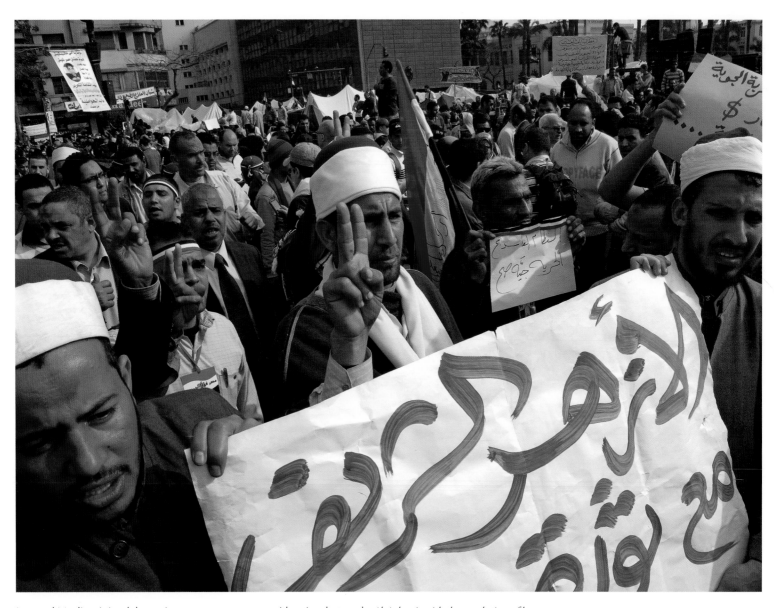

Learned Muslims joined the anti-government protests with a sign that reads: *Al-Azhar is with the revolution of hope.*

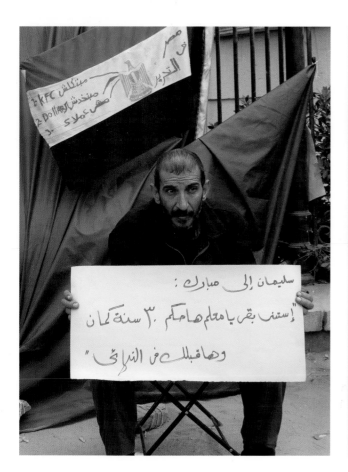

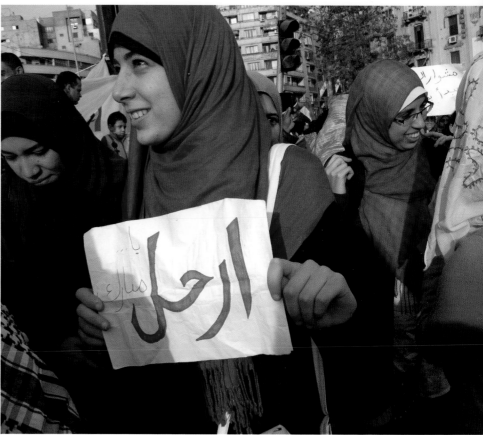

The blue board has Omar Suleiman, who was appointed to the long vacant vice-presidency by Mubarak in a desperate move on 29 January, ready to take power and keep it for at least as long as Mubarak did: *Just wait, pal, I'll rule for 30 years now, and I'll meet you in the finals.*

The most heard and seen word at Tahrir Square until Mubarak stepped down was *Irhal: Leave.*

THE EGYPTIAN PEOPLE for a long time have been at the bottom of the proverbial pyramid. At Tahrir Square the pyramid was all of a sudden standing on its head.

The spirit of freedom brought together our dismembered nation, as the goddess Isis assembled the pieces of Osiris's broken body. Barriers of fear fell to the ground, allowing our differences to be shared. Finally we were exercising our strength instead of taking advantage of our weakness, as we had learned over the millennia to do as an oppressed people. And we celebrated our new freedom with a great deal of artistic invention. A man held up a banner that read: "When you have been scalded by the hot soup, you blow on the yoghurt to chill it." For the first time in my life, I can actually believe in the expression "Where there is a will there is a way."

—**Hassan El Geretly**, theater director

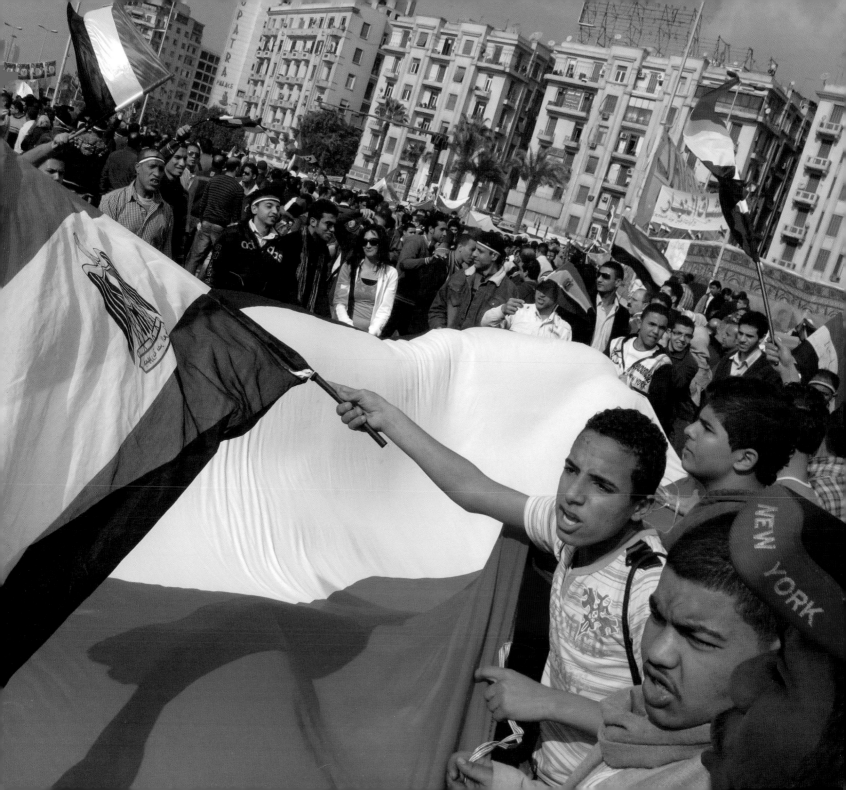

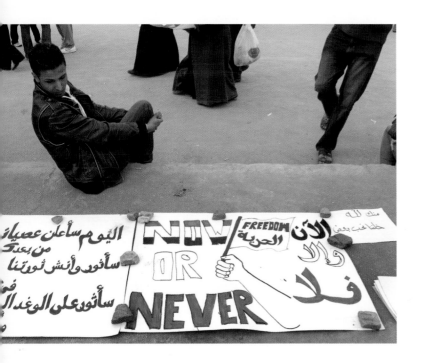

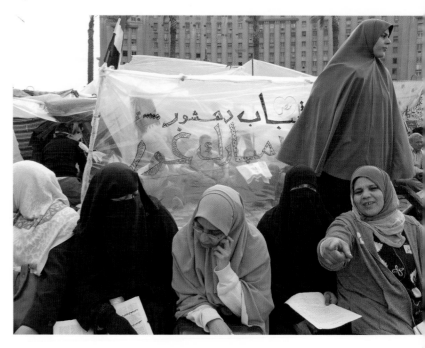

The writing on the tent rhymes: *Yaqul shabab Dahshur: ya Mubarak ghur —The youth of Dahshur say: Mubarak, get lost!*

Right: The writing on the asphalt informs: *This is the state land distribution center. Martyrs Square (Tahrir). Signed: A citizen.*

Far right: Spontaneous dancing and chanting at the entrance to Tahrir Square: *Muslim, Christian, we are all Egyptians!*

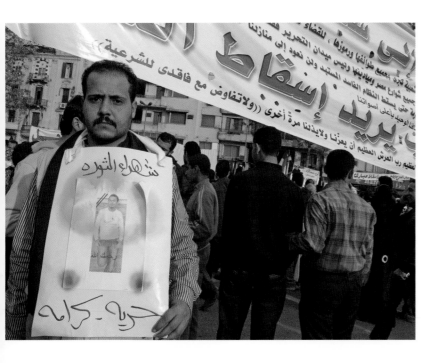

The board reads: *Martyrs of the revolution—freedom, dignity*.

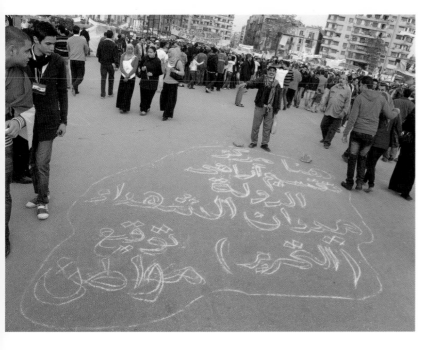

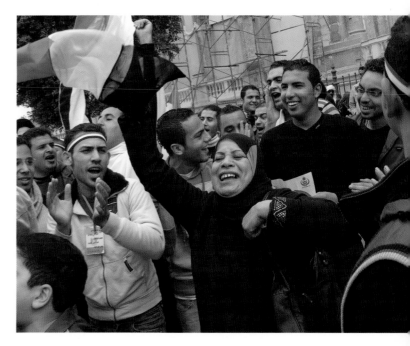

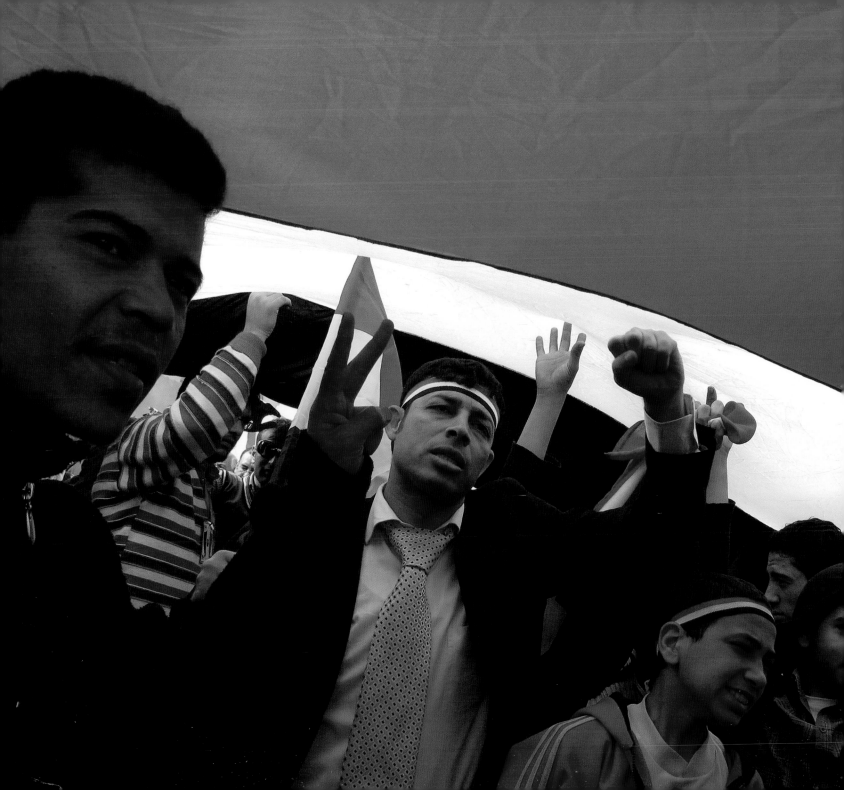

THE PEOPLE I SAW IN TAHRIR SQUARE were new Egyptians, with nothing in common with the Egyptians I was used to dealing with every day. It was as if the revolution had recreated Egyptians in a higher form. In Tahrir Square I saw Egypt fully represented: Egyptians of all ages and backgrounds, Copts and Muslims, youngsters, women, the old, children, women in hijab and women without, rich and poor. Millions of people took a stand in Tahrir Square, living together like members of the same family."

—**Alaa Al Aswany**, writer

Left: Under the same flag. Christians, Muslims, and people from all sectors of society join together for change.

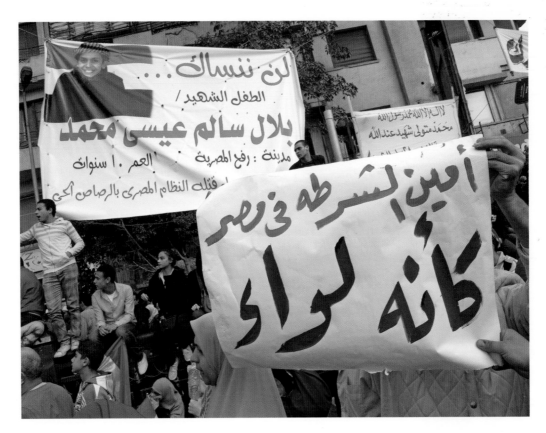

The banner with the portrait says: *We will not forget you. The child martyr Bilal Salem Eissa Mohamed, from Rafah, 10 years old, killed by the Egyptian regime with live fire*. The placard at bottom right reads: *The policeman in Egypt is like a major-general*.

Right: Pictures of martyrs killed in the uprising line a makeshift wall at Tahrir Square, 9 February.

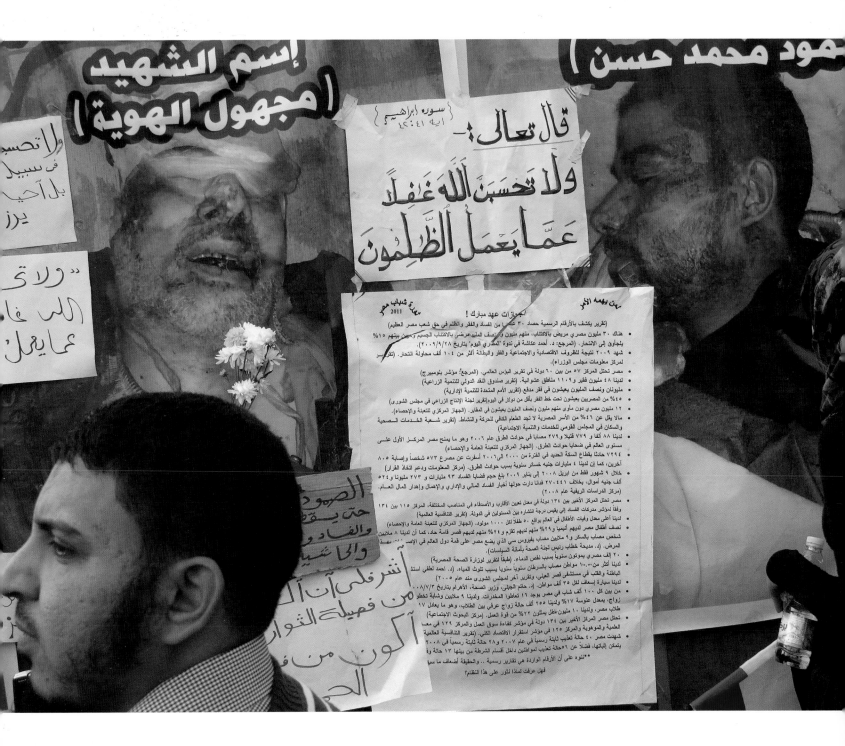

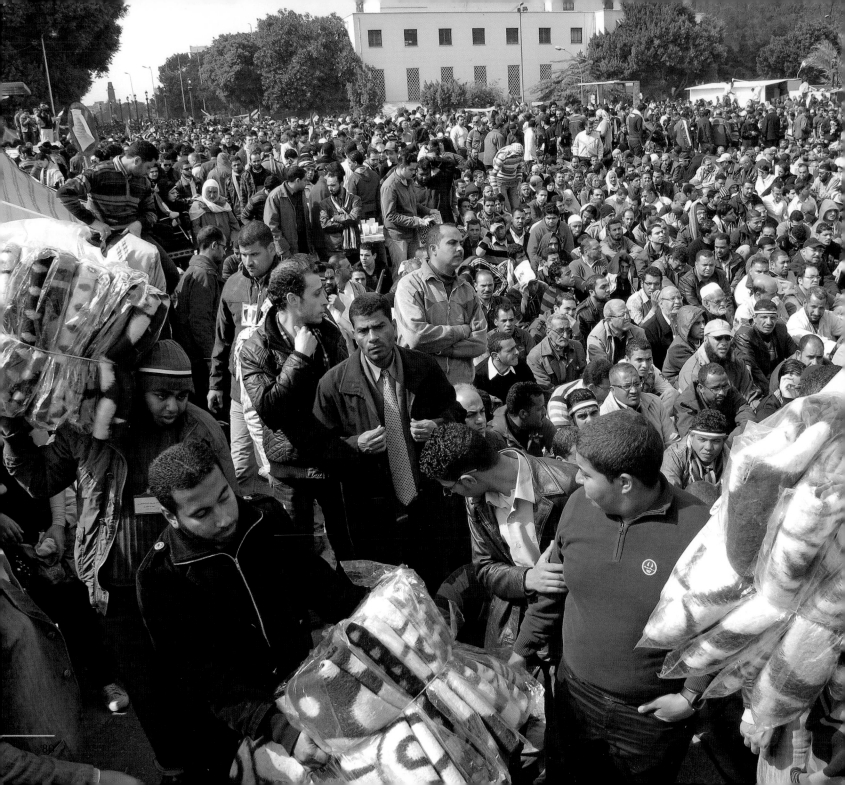

Blankets are brought in by
volunteers to the people
who protect Tahrir Square
during the night.

I WENT TO TAHRIR to offer my help as a physician. For a long time I've been very angry and upset about the great discrepancy between poor and rich in my country. As a pediatrician I often see children who are malnourished because they have to skip meals in order for every family member to eat something. I was greeted with sweet dates, singing, and smiling people when I arrived. I found a small clinic in a corner of the square and colleagues treating protesters who had been injured by Mubarak's police. I was astonished by the strong solidarity at Tahrir; a great change had already happened to Egypt.

—**Inas Mazen**, professor of clinical genetics

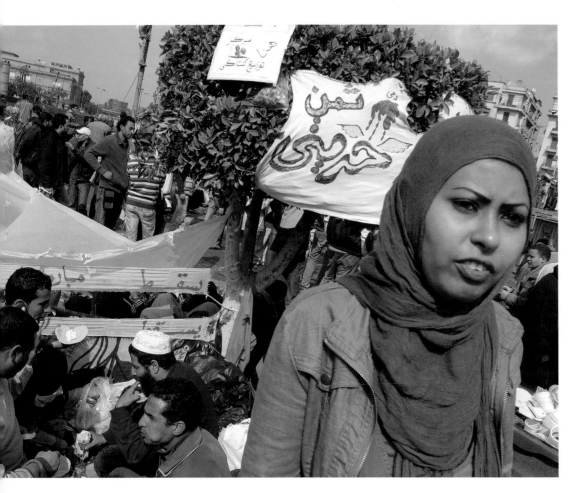

The banner on the tree says: *My blood is the price of my freedom*.

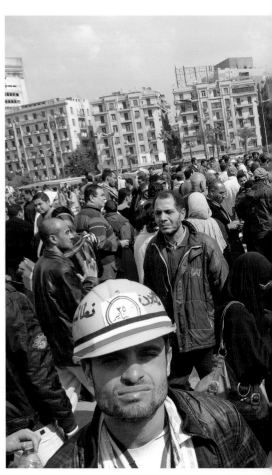

The man on the fence holds a placard that reads: *Emergency only*.

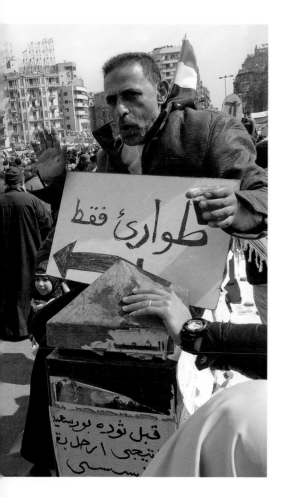

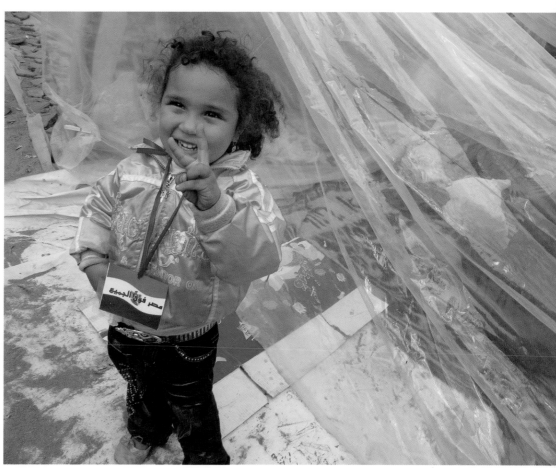

Haya makes the sign of victory outside the shelter of plastic sheets where she sleeps with her parents at Tahrir. Haya wears the Egyptian flag as a necklace, with the words: *Egypt above all*.

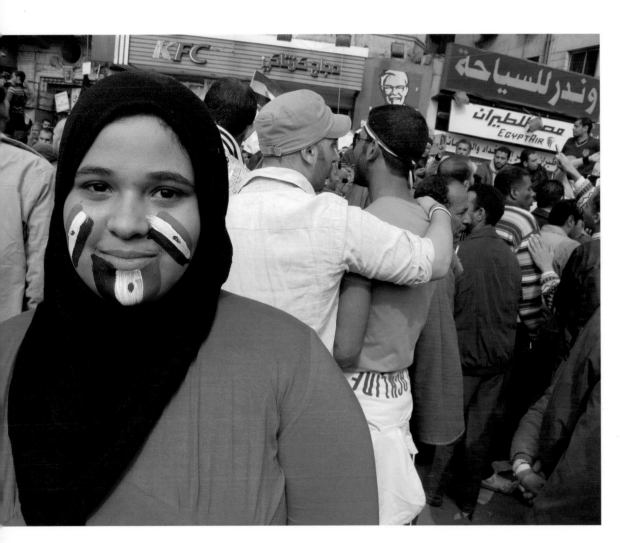

A sense of overwhelming pride filled Egypt's youth after the January 25 revolution.

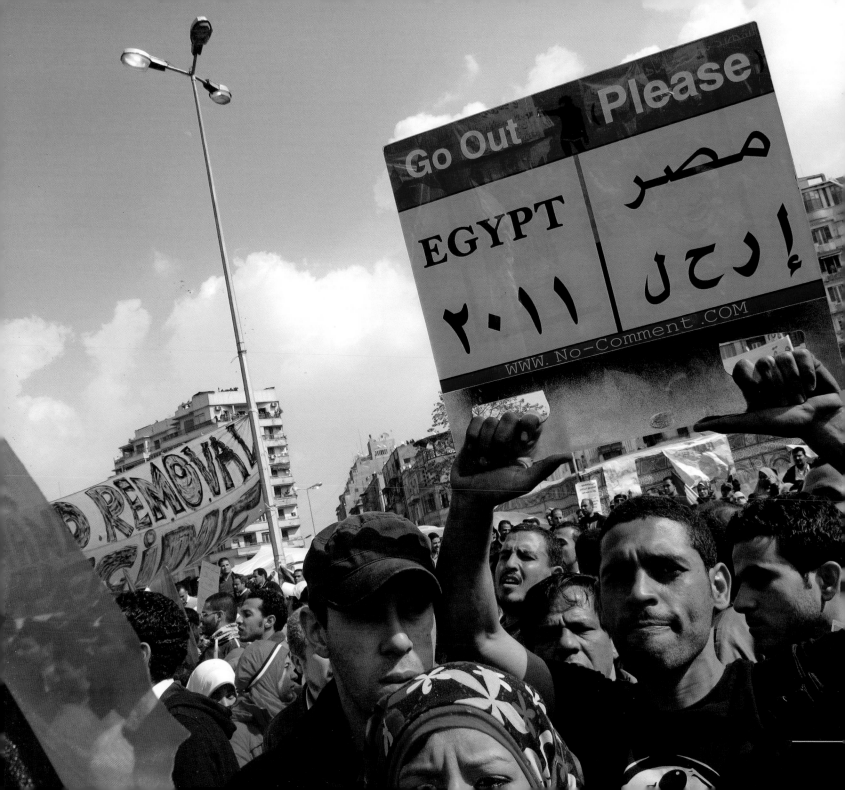

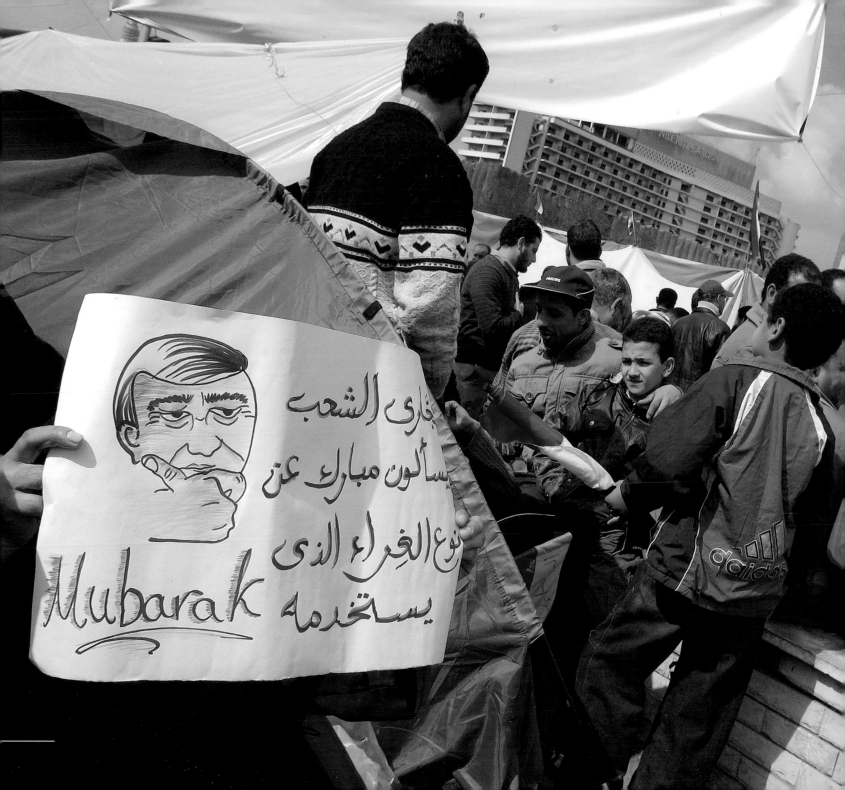

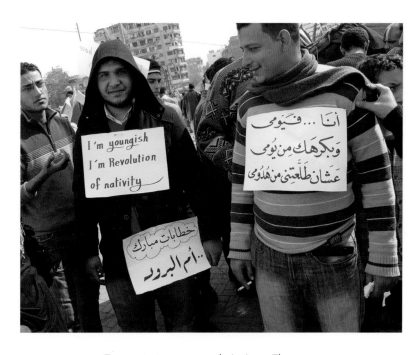

Two protesters express their views. The young man's sign on the left reads: *Mubarak's speeches are the height of arrogance.* The man next to him has arranged his slogan in a rhyme: *Ana fayyumi; wa bakrahak min yumi; 'ashan talla'tini min hudumi.* —*I'm from Fayoum, and I hate you from the day I was born, because you took my clothes.*

Left: The revolt has reached its eighteenth day, and this protester holds a sign that reads: *The carpenters of the people ask Mubarak what kind of glue he's using.* Later in the evening Mubarak finally resigns.

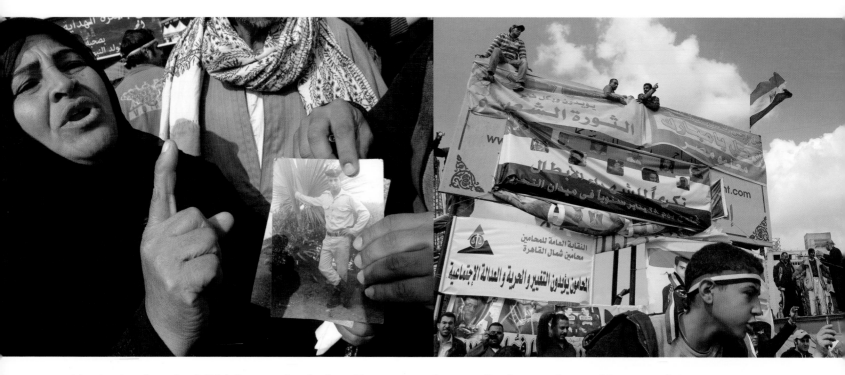

A bereaved mother arrives in Tahrir Square to share her loss with the protesters. Her son Mahmoud was killed during the first days of the revolution.

Banners calling for remembrance of the martyrs of 28 January, among messages of support from teachers, lawyers, and other groups.

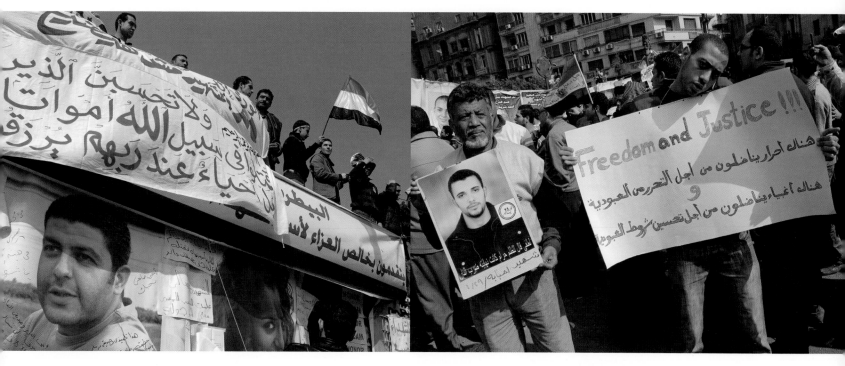

A banner for the martyrs reads: *Those killed for the sake of God are not dead but alive with their Lord.*

The writing below the portrait to the left says: *Lutfi said "No to oppression," and he was shot. Martyr of Imbaba, 29 January.* The placard to the right reads: *There are free people who are fighting for liberation from slavery. There are stupid people who are fighting to strengthen the bonds of slavery.*

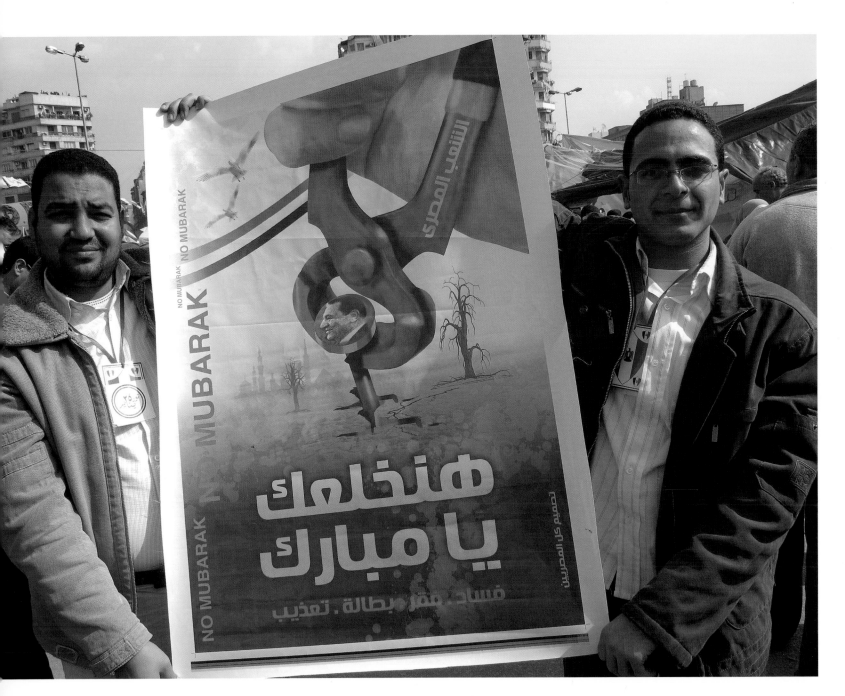

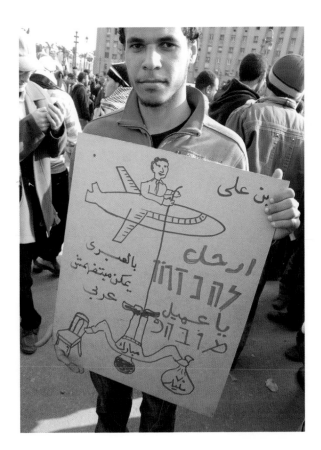

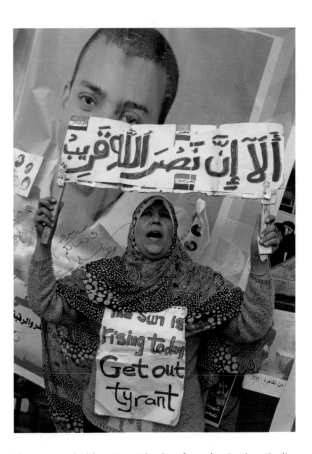

Tunisia's ousted leader Ben Ali pulls Mubarak up to his plane with his bag of 70 billion dollars. The text on the simple cardboard sign reads: *Leave, stooge. In Hebrew in case you don't understand Arabic.*

Left: A poster against Mubarak and the evils of his regime: corruption, poverty, unemployment, and torture. On the pliers is written: *The Egyptian people.* The writing in yellow says: *We will pull you out, Mubarak.*

This woman holds a sign with a line from the Qur'an: *God's victory is surely near.* The giant portrait in the background is of her son Mustafa al-Sawi, 26. He was killed by the police on Friday 28 January at the battle for Qasr al-Nil Bridge, which leads into Tahrir Square.

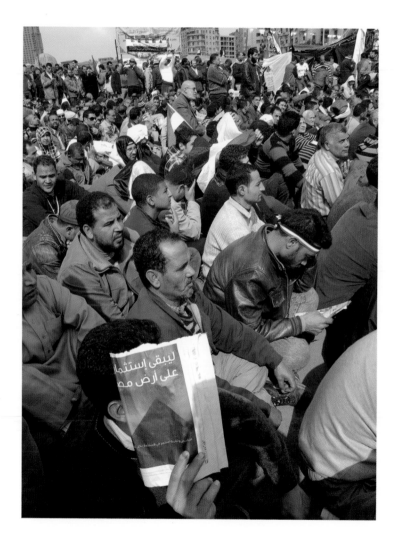

Protesters pause for
prayers in Tahrir Square.

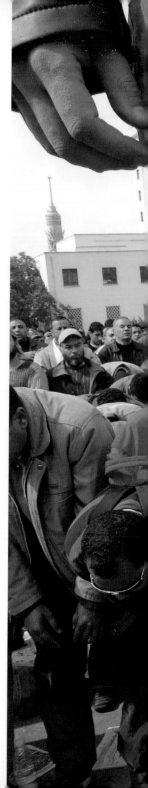

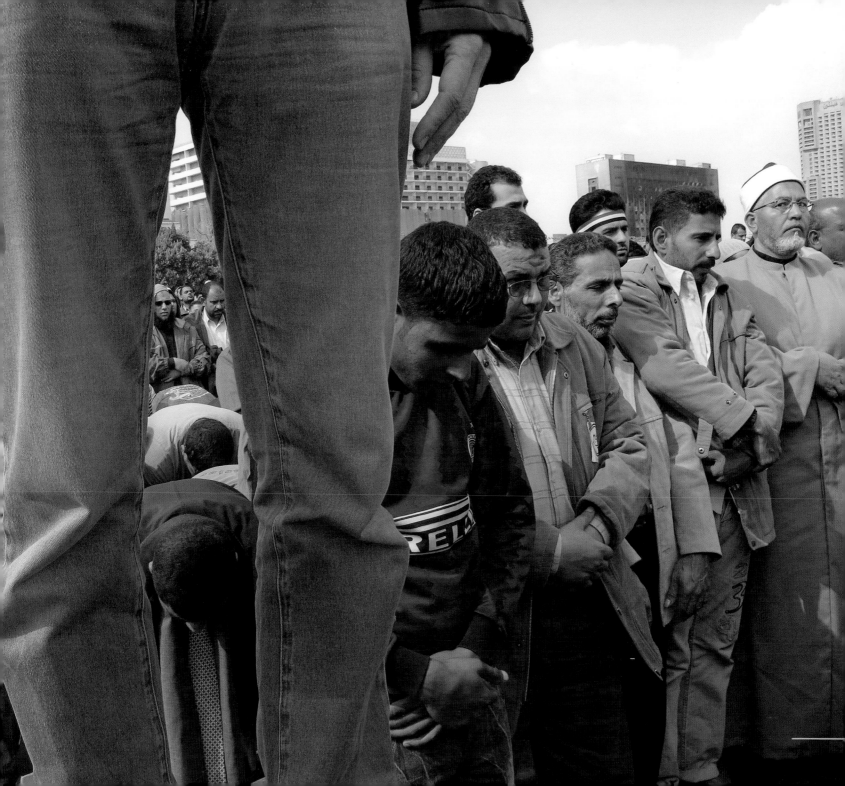

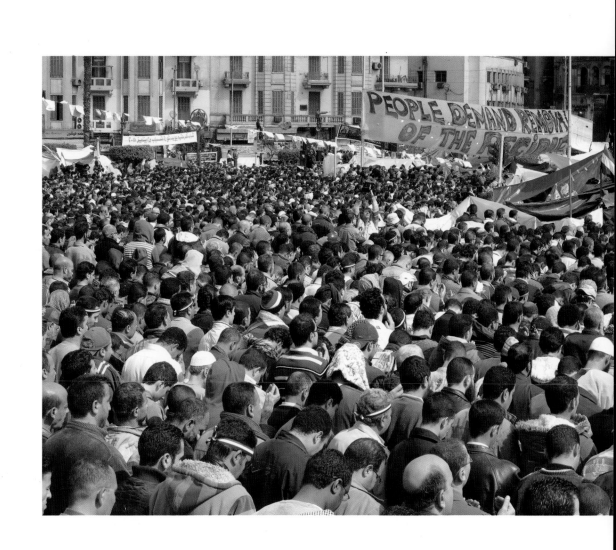

I WOKE UP ON 11 FEBRUARY believing this would be my worst birthday ever. The evening before, Thursday, we had been expecting Hosni Mubarak to leave, but he hung onto power and we all felt miserable. In this sad state of mind I went to Tahrir on my birthday, together with my family and colleagues, to join the protests. I was surprised to find, despite the anti-climax of the previous evening, a square filled with festivities, as if people felt that this day, Friday, instead was going to be *the* day.

It was like a mulid, with people strolling around, many carrying funny jokes on placards, there was music, friends greeting each other, a lot of joy and warmth, but I still wanted more for my birthday. And a few hours later we got the news: Mubarak had given up at last and we were free. My birthday became the best in my life. I cried and laughed and hugged everybody in Tahrir Square. We sang, we waved flags and chanted: "You are Egyptian, raise your head!" I'm so proud of being Egyptian.

—**Mona Abou el Ghar**, professor of gynecology

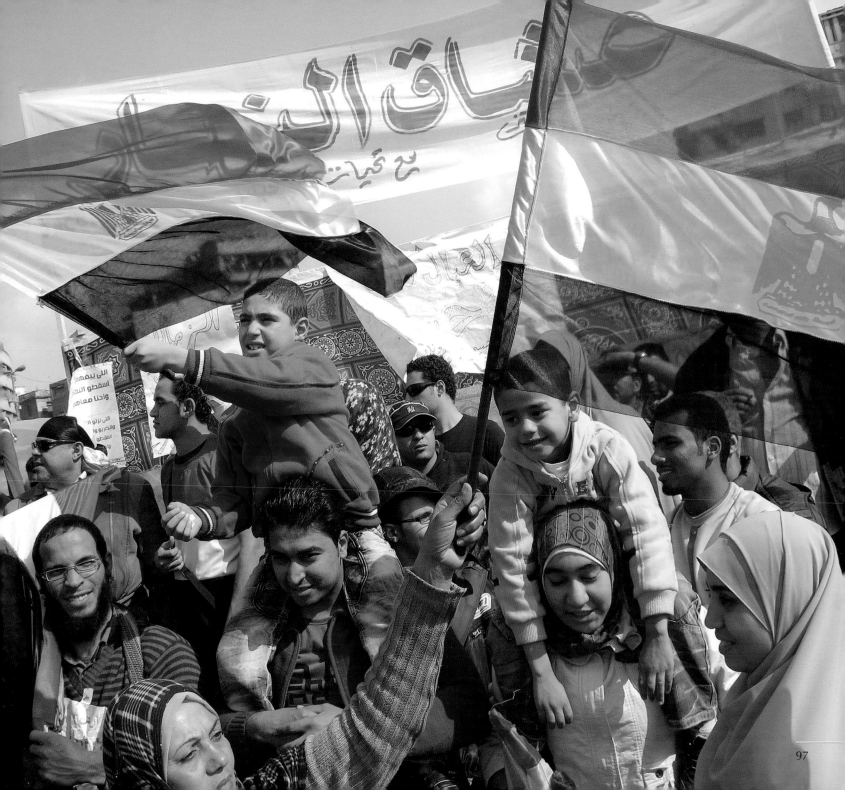

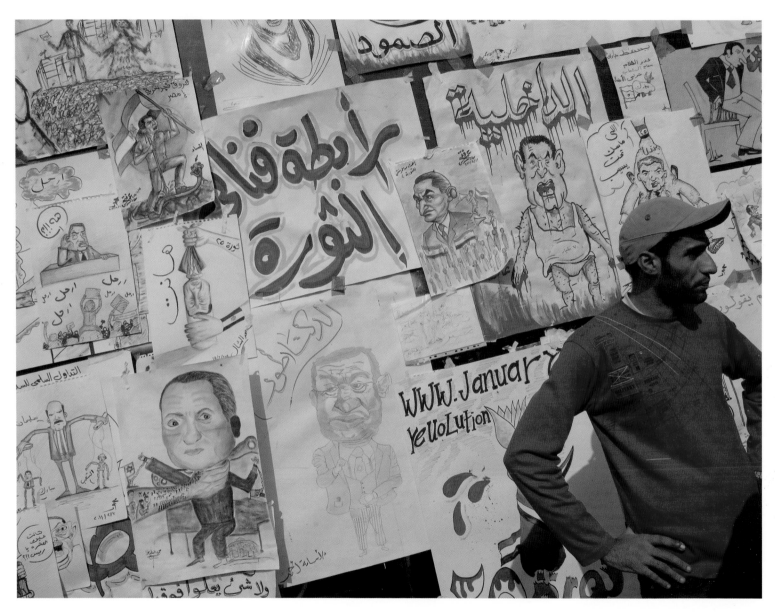

Artwork at Tahrir. Next to the street clinic was an exhibit of cartoons, most of them caricatures of Mubarak, produced by *The Union of Artists of the Revolution*.

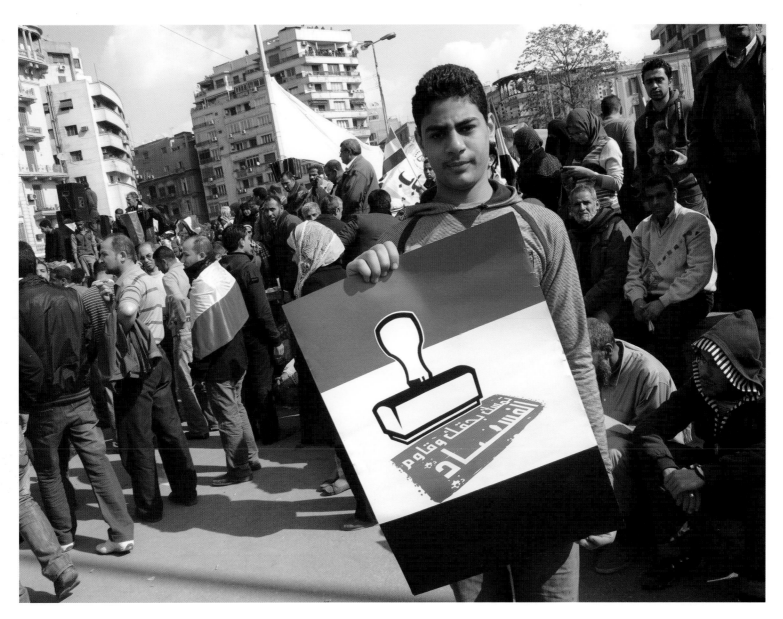

The placard urges: *Insist on your rights and fight corruption*.

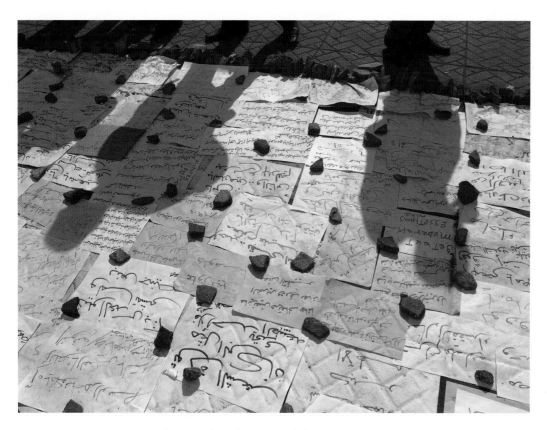

After more than thirty years of silence, people's joy in expressing themselves freely knew no limits.

Right: Messages on display at the scribes' shelter. The pink placard carries a long poem called *Tahrir Revolution*; its bottom line says: *Mubarak, your abode will be the garbage dump of history*. The white sign says: *The people want the execution of the president.*

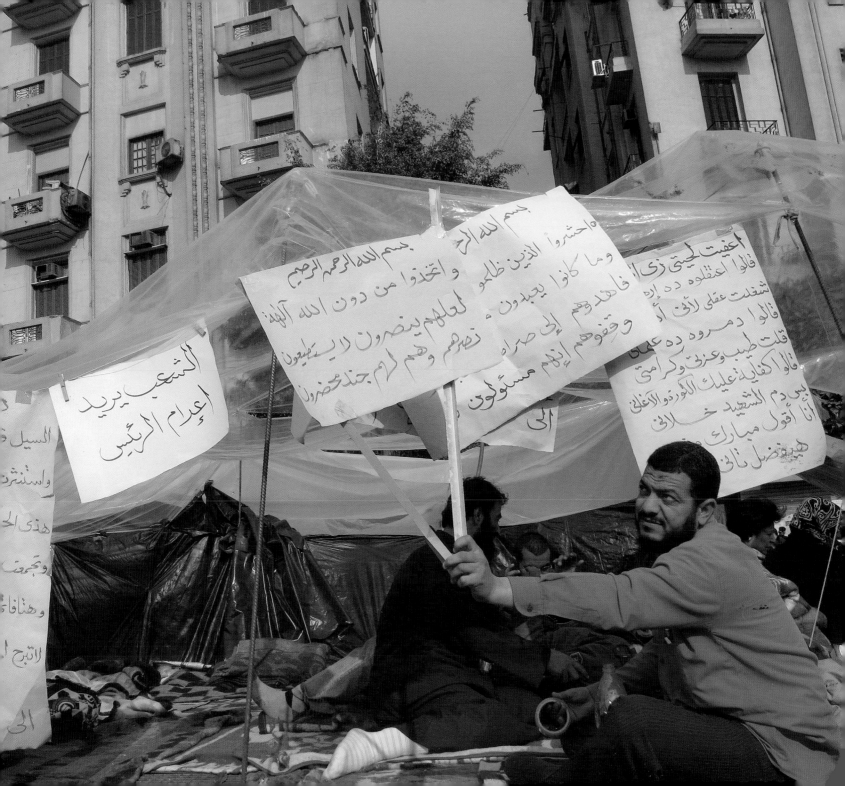

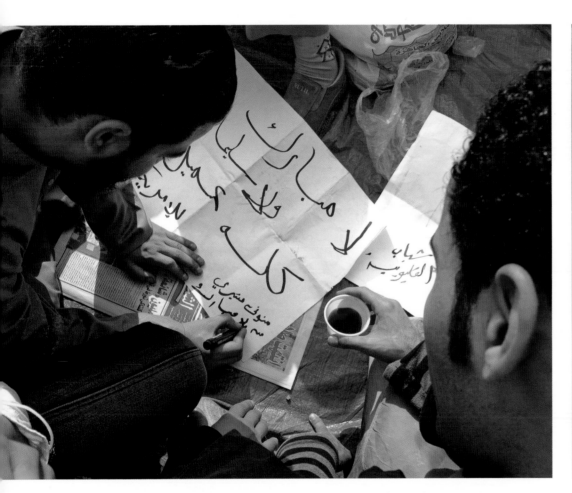

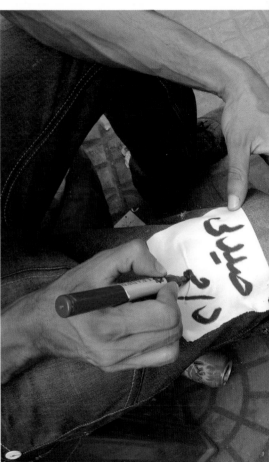

Scribes were ready to write slogans on request at several places around Tahrir. Here a new placard is being produced with the text: *Neither Mubarak nor Suleiman; they're all agents of the Americans.* (*Suleiman* and *the Americans* rhyme in Arabic.)

Writing a name tag for a man who has volunteered to work at the street clinic: *Pharmacist/ Dr. M . . .*

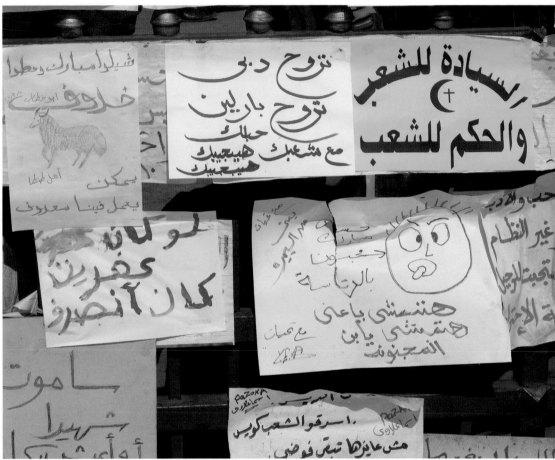

A fence of slogans. The yellow placard reads: *Sovereignty of the people and rule of the people*. The poster with a face says: *Hosni Mubarak the megalomaniac; You'll leave whether you like it or not, you crazy bastard*. The sign at top left, with the sheep, rhymes: *Shilu Mubarak wa huttu kharuf; yimkin yi'mil fina ma'ruf. —Remove Mubarak and install a sheep: it might treat us more kindly.*

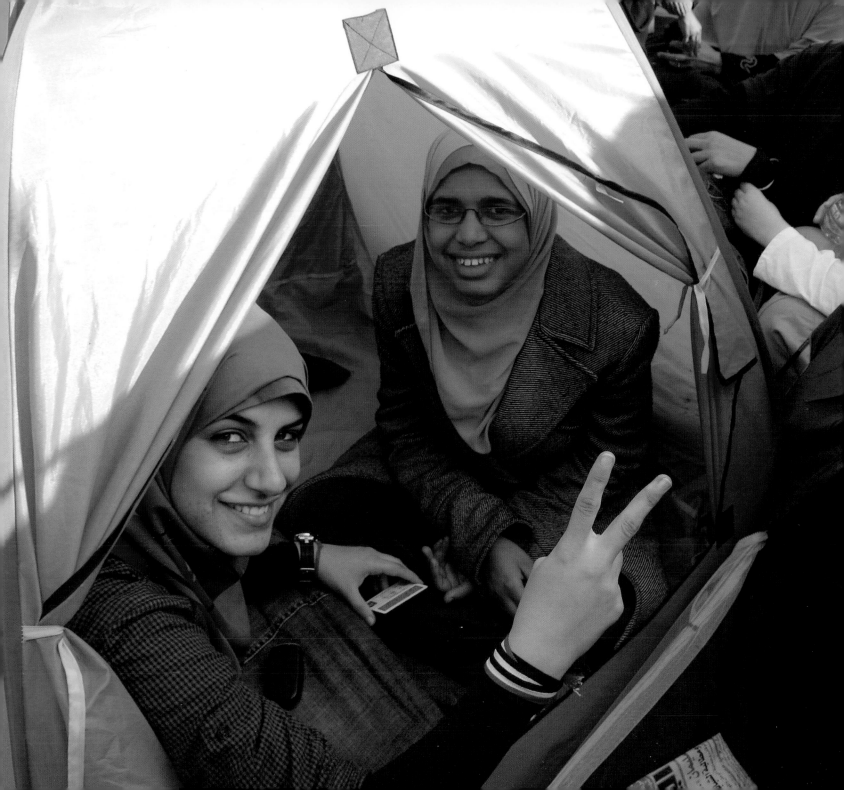

Checkpoint for women entering Tahrir Square, run by female volunteers to ensure that police and pro-Mubarak thugs don't get in. Everyone had to pass several checkpoints before being allowed to enter the square.

Left: Women made up 30–50% of the protesters in Tahrir; many of them slept on the asphalt in tents or makeshift shelters during the eighteen days of the uprising.

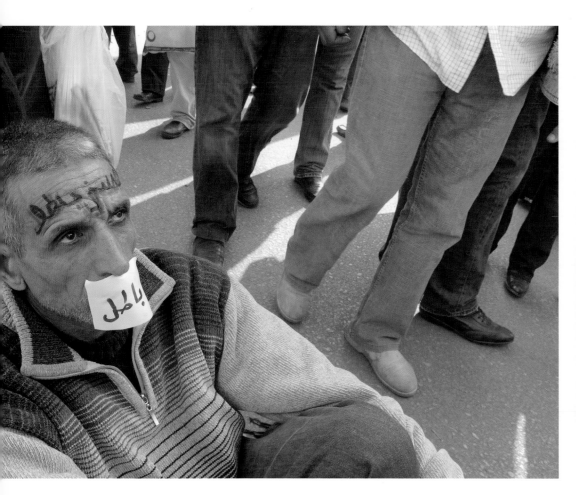

Amid the protesters at Tahrir a man holds a sit-in on the asphalt. The writing on his forehead says: *Hosni is illegitimate*. The piece of paper over his mouth reads: *Illegitimate*.

A corner for reading newspapers.

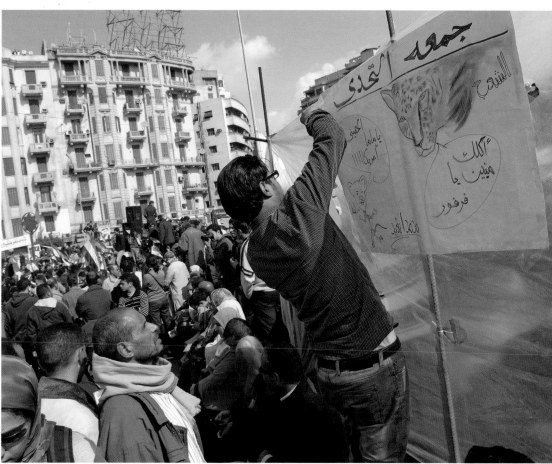

A placard carrying the title: Friday of Challenge. A cat—the people—plays with Mubarak, the mouse. The cat: *How shall I eat you, little mouse?* Mouse: *Help me, Mama America!*

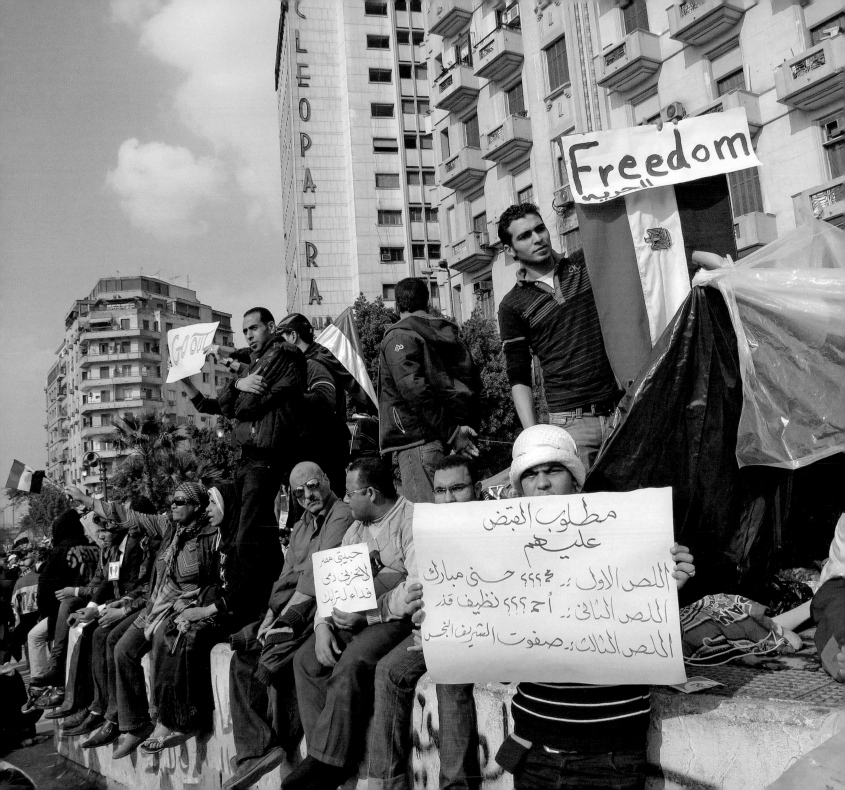

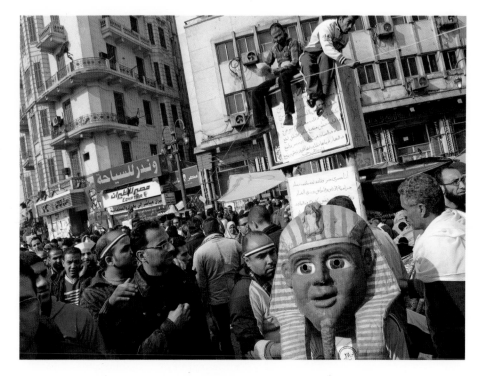

In the second week of the revolt, Tahrir Square turned into a fairground where anything could happen; here, Tutankhamun has joined the pro-democracy protesters

Left: The placard at the front lists the crooks of the old regime. The witty writer has played with their noble-sounding names, and given them new ones within parenthesis: *Wanted: The first crook: Hosni Mubarak. The second crook: Ahmed Nazif (Qazir). The third crook: Safwat al-Sherif (al-Nigis). Nazif* means 'clean,' *qazir* means 'dirty; *sherif* means 'virtuous,' *nigis* means 'unclean'. Ahmed Nazif was prime minister until 29 January. Safwat al-Sherif was the head of the National Demoratic Party.

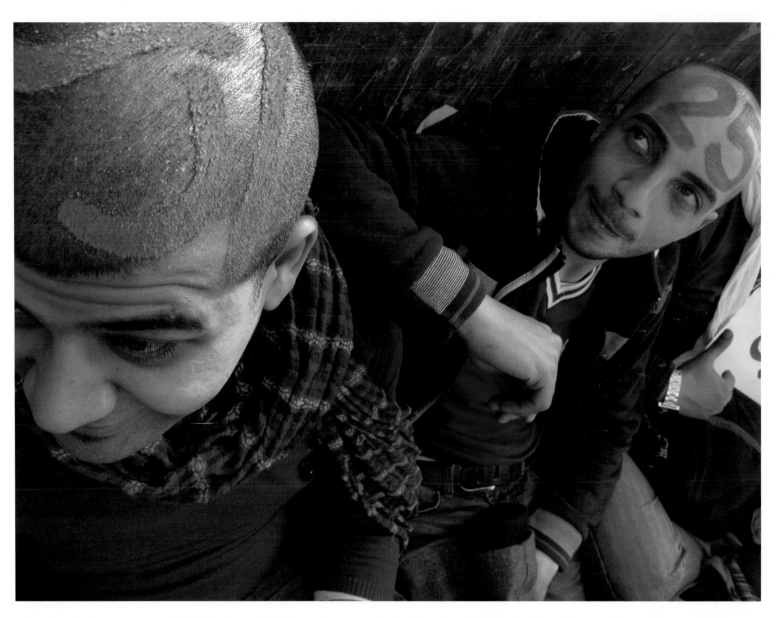

Talking heads. The young man to the left has the word *Irhal* (Leave) written on his head. His friend's forehead refers to the start of the revolution on 25 January.

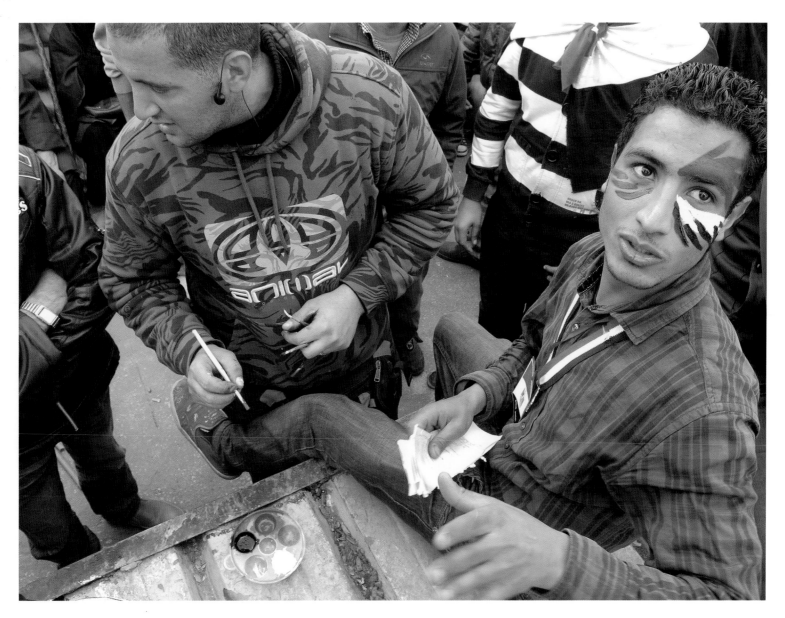

Artistic face paint in the colors of the Egyptian flag.

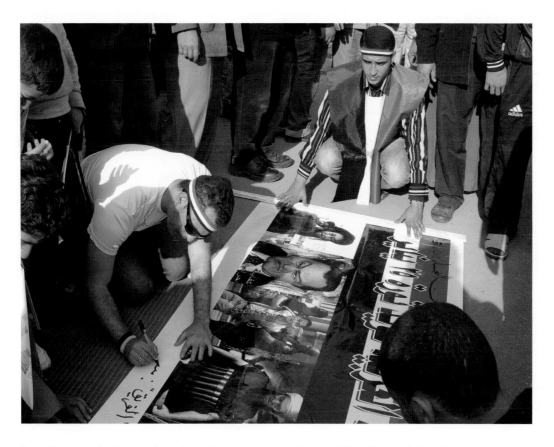

Tens of thousands slogans, placards, and banners were produced at Tahrir Square during the revolt.

Right: Burned-out prisoner-transport truck painted with graffiti. Behind the pasted sign is a caricature of Mubarak drawn in white.

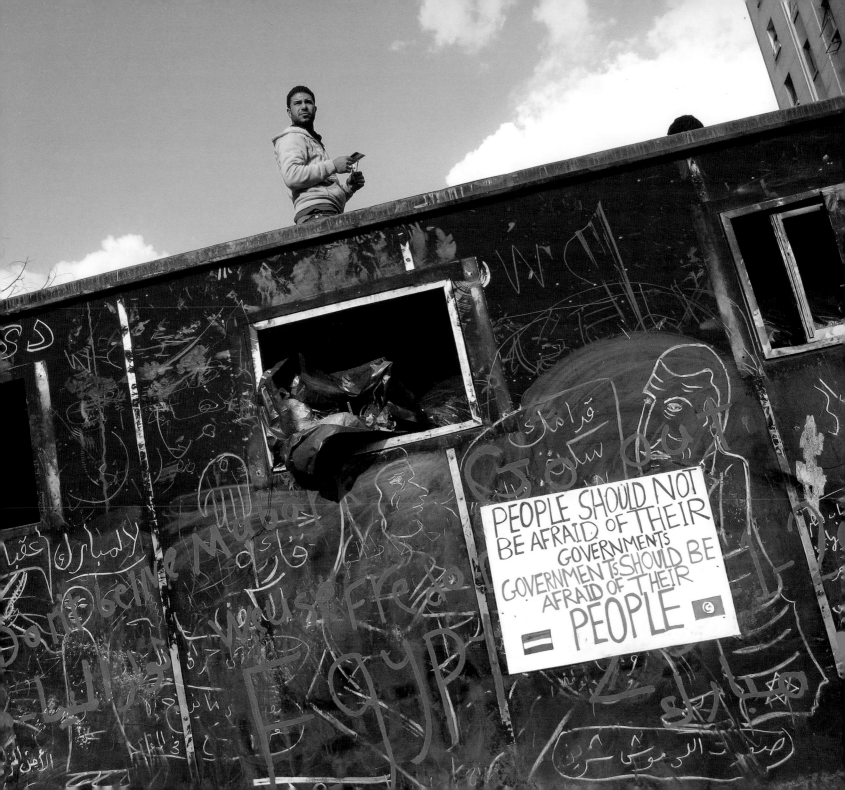

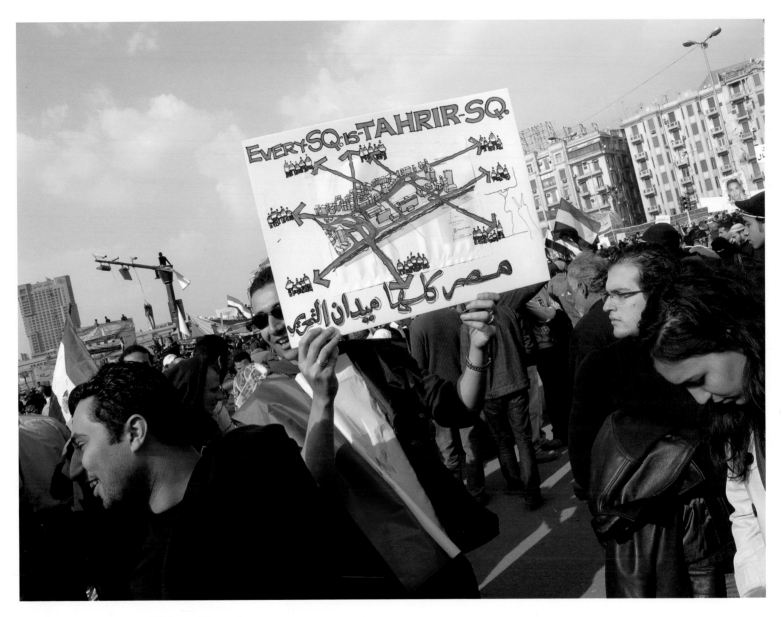

All Egypt is Tahrir Square, reads the Arabic on the sign.

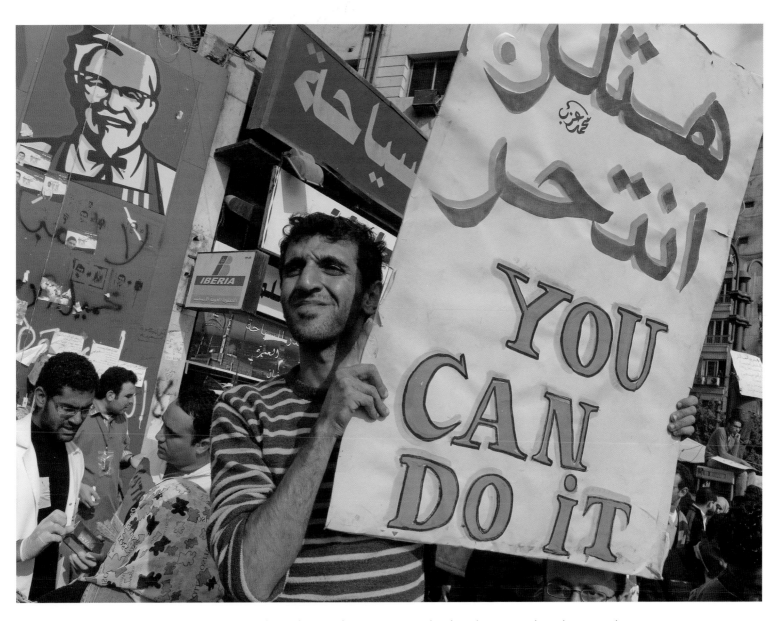

In front of the street clinic at Tahrir Square a man holds a pink sign with a message to Mubarak: *Hitler committed suicide. You can do it*.

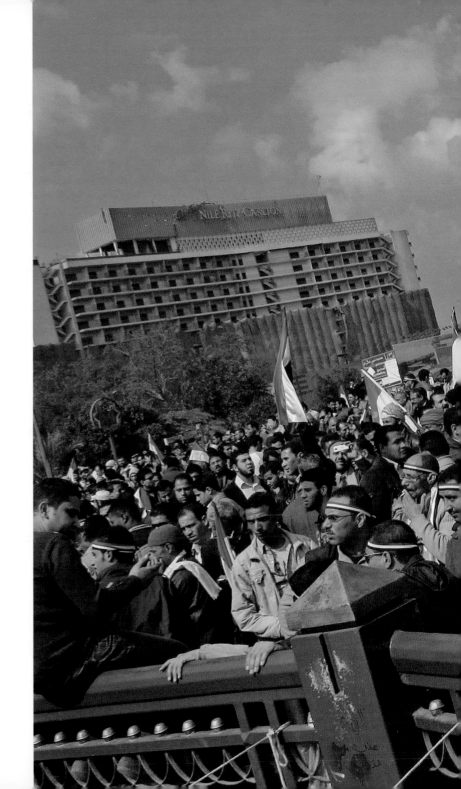

A protester holds a placard that wants *The End* to: *oppression, bribery, discord, influence, corruption, repression*. The sign to the right in the background, reads: *Our revolution toppled the throne.*

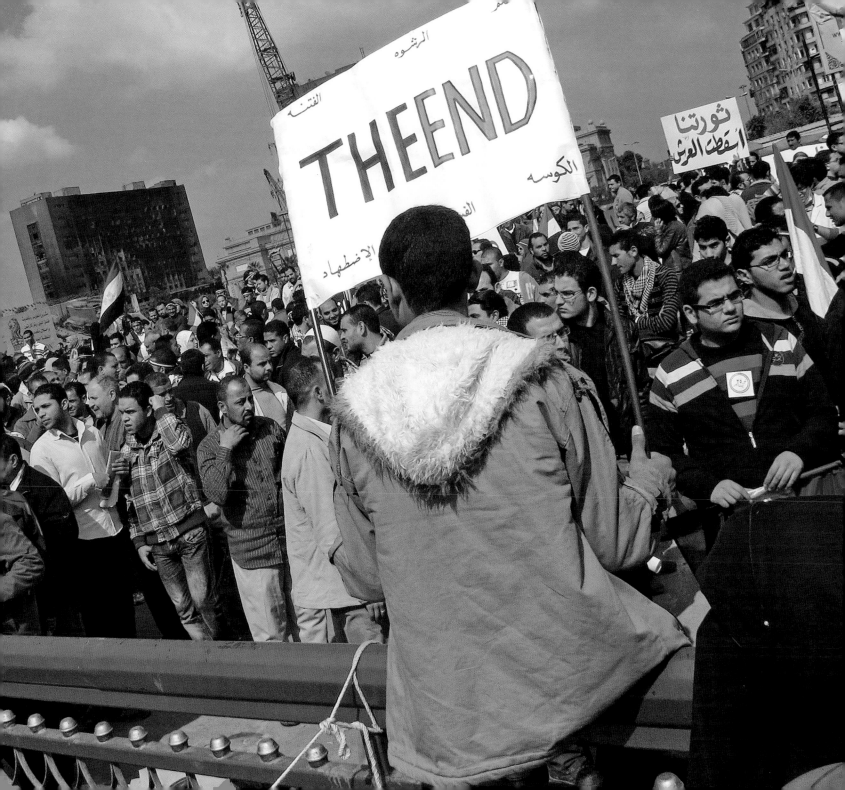

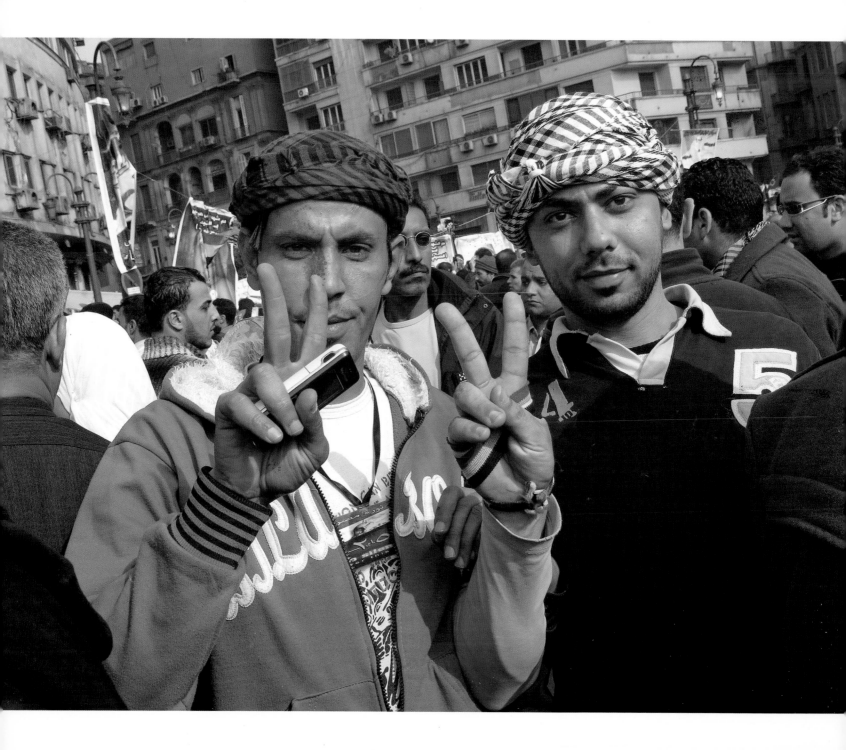

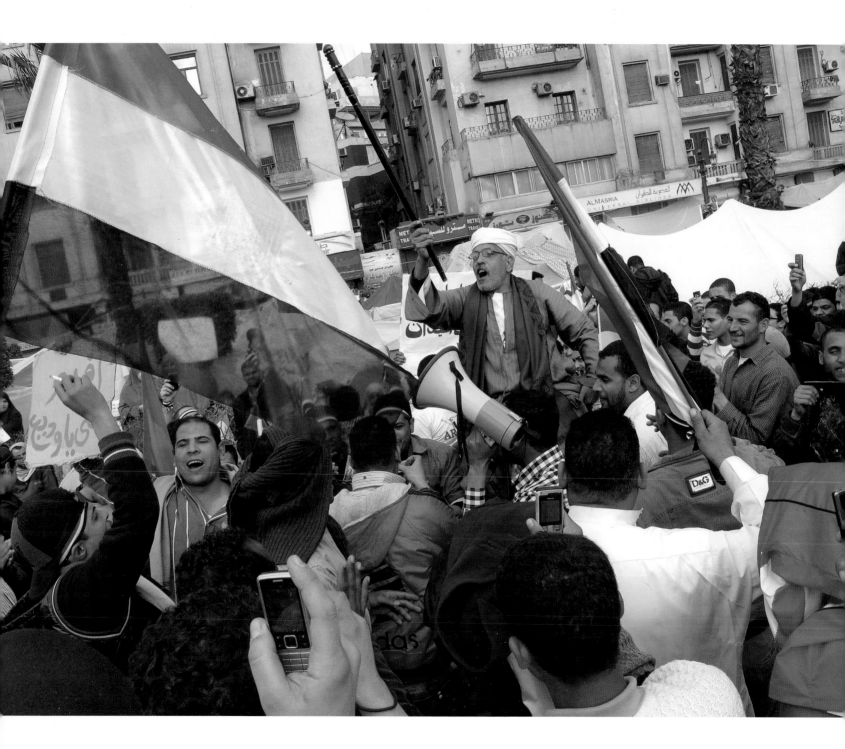

I HAVE BEEN LIVING IN EGYPT for many years and I consider myself part of this society, so it was impossible to stay away from Tahrir. I will never forget the day Mubarak left. It was amazing, everyone was hugging each other, dancing and laughing. It was a hysterical mix of joy, tears, love and happiness.

—**Naseer Shamma**, Iraqi musician

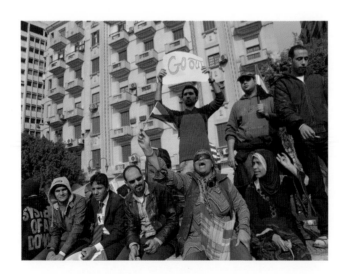

At 6pm on 11 February, Hosni Mubarak finally heeded the demand to *Go out* and left his post as president of Egypt.

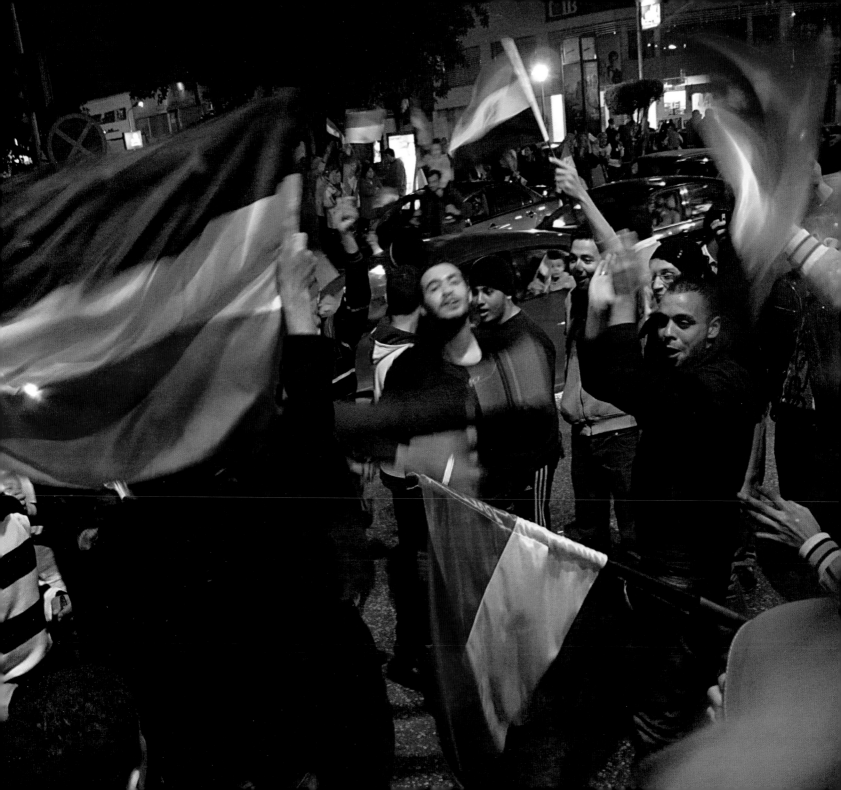

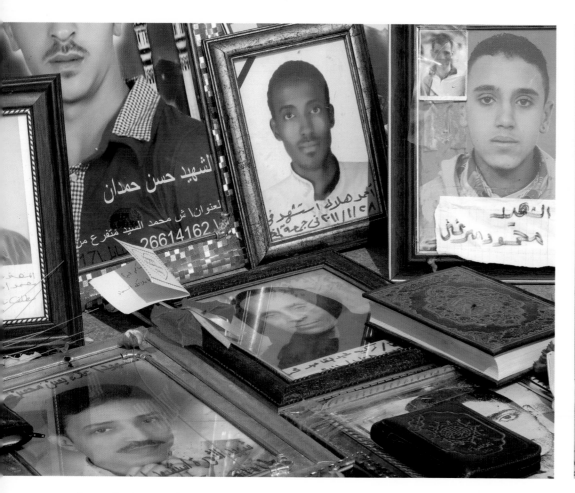

A shrine of portraits, garlands, and flags to the martyred was set up at Tahrir. In the center, Ahmed Hilal, shot by a sniper on 28 January in protests at Maadi, southern Cairo.

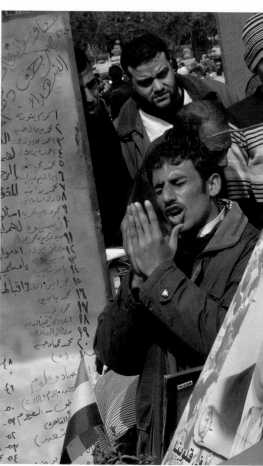

A mourner at the Tahrir shrine.

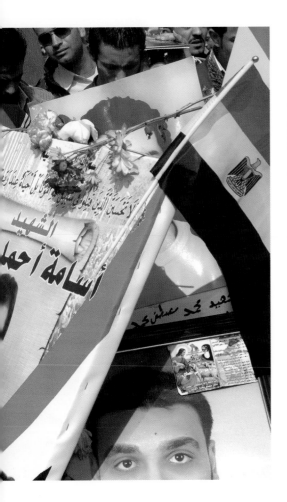

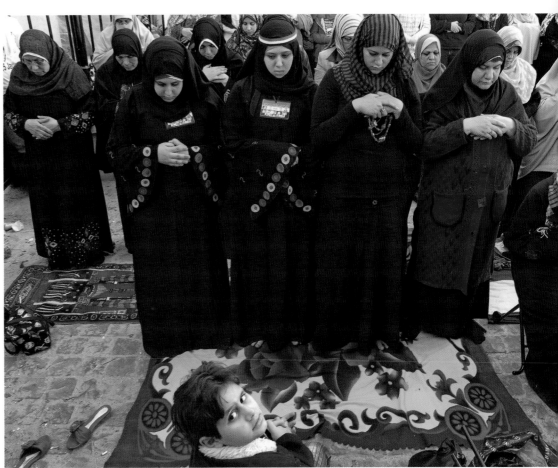

Noon prayers.

Graffiti on a window at a KFC fast food restaurant taken over by the protesters.

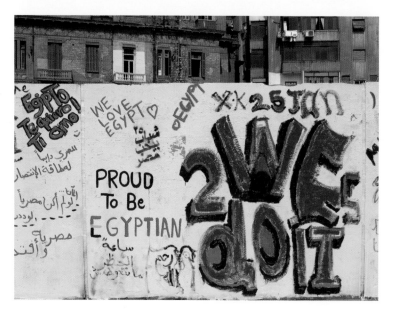

Egyptian graffiti artists celebrate the revolution and the downfall of Mubarak.

Right: Mural painted on the wall along Mohamed Mahmoud Street, leading to Tahrir Square.

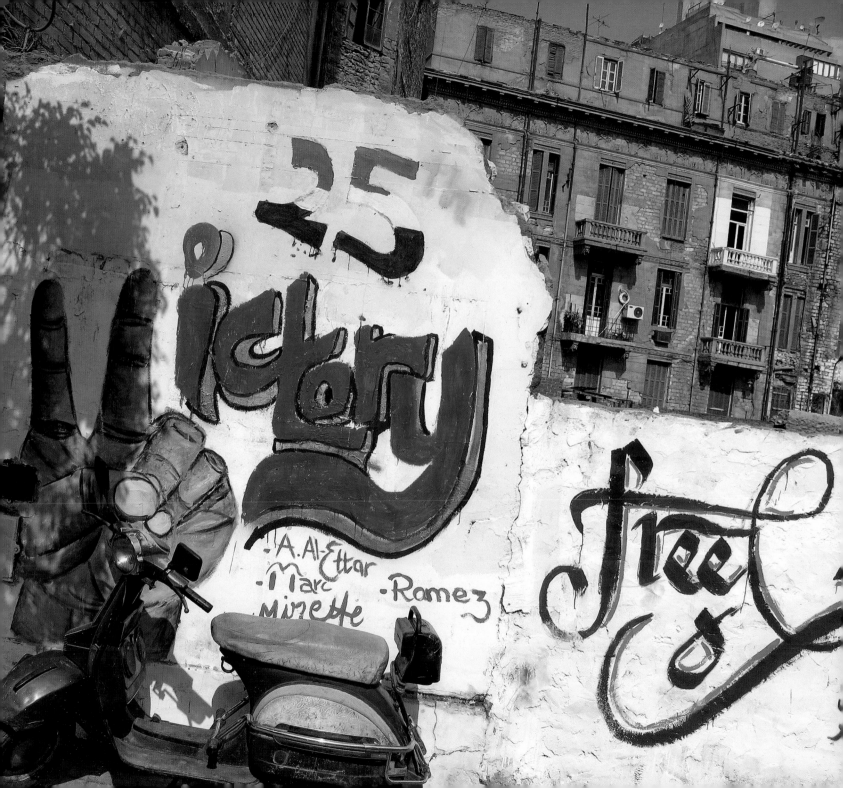

BEING IN TAHRIR was a three-week-long emotional, sensory, and cognitive rollercoaster ride. There were moments of euphoria, terror, depression, humor, and pride. There were military tanks, F16 planes, and sword-bearing thugs on camels and horses. The flow of information and rumors was torrential. . . . It was an overwhelming experience in every sense of the word.

—**Ghada Shahbender**, human rights activist

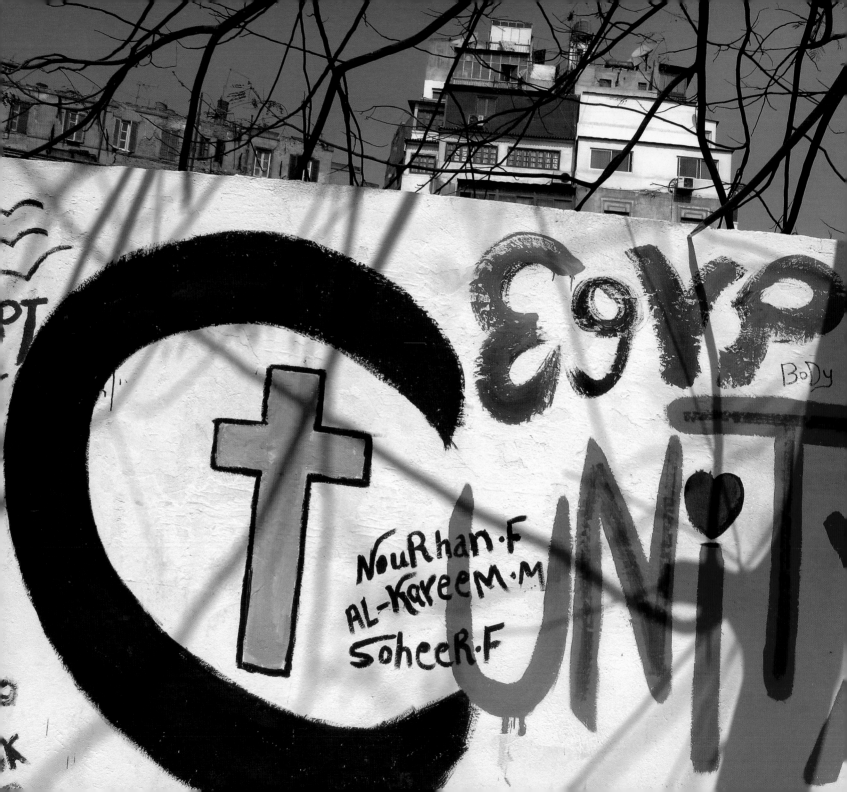

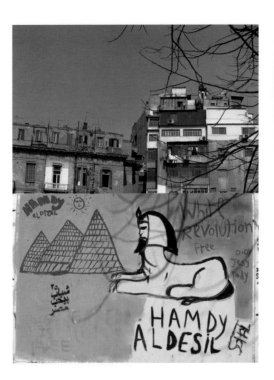

Today the Sphinx and the Pyramids are accompanied by another big tourist attraction: Tahrir Square.

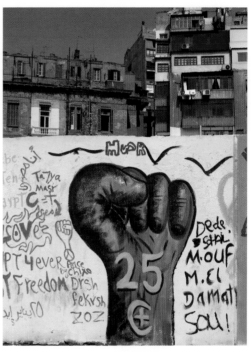

For the first time, revolutionary street art and graffiti were painted and sprayed on the walls of Cairo.

Left: Graffiti in support of the unity between Muslims and Christians in Egypt.

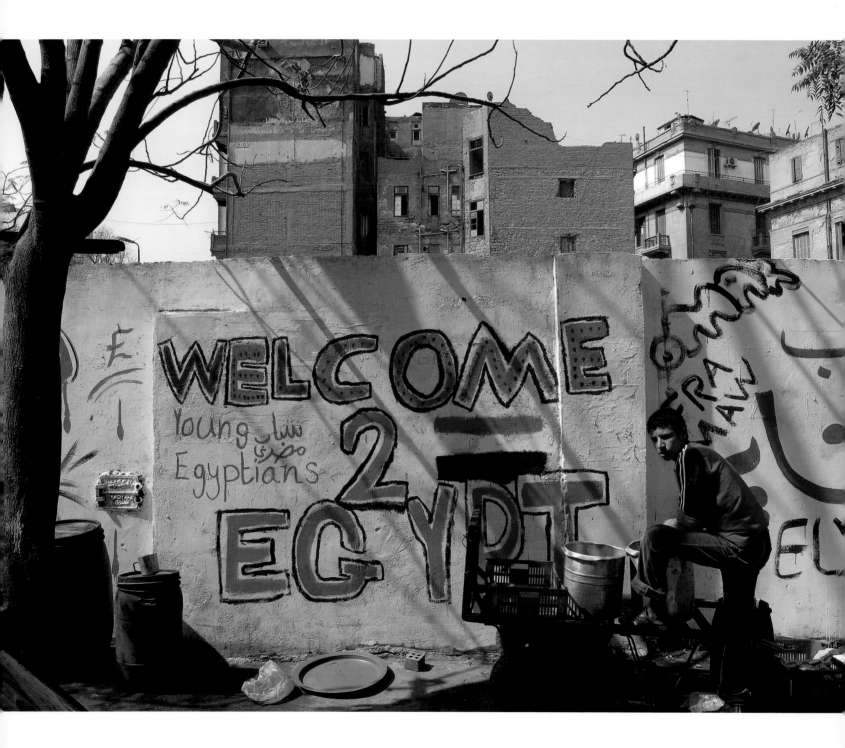

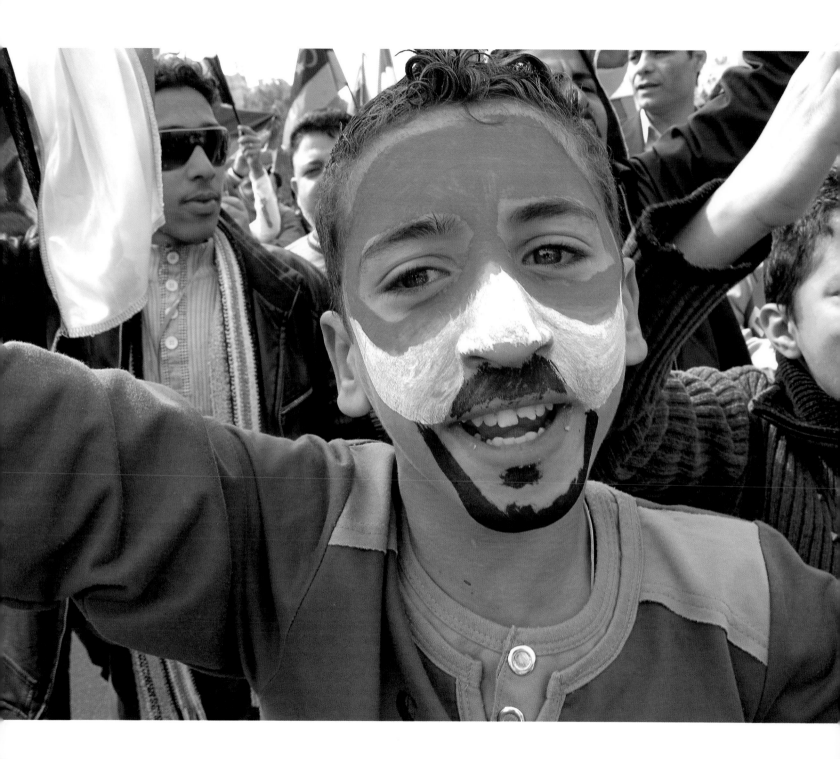

MOTHER OF THE GROOM

Your son did not die.
I saw him in the noon call to prayer.
Come
to well-being.
I saw him today buying
Light for the morning,
Standing
At the door
That leads
To our lives, ushering people through to
 the vastness.

Your son is a story to be drawn
And a picture to be told for the sake of God.
Your son is the alleyways of patience
In the country of desires.

O mother of contentment,
Neither the cruelty of the sniper
Nor the action of the bullet,
Neither the marksman wounding the breeze
Nor the bullet
Can beat the divining of the seashells.

The hour of your contentment
In a long
Night
Is what pointed out the brave man
From the day you stifled your scream.

O mother of the groom,
Your son is in the hands of pain.
Pull back the curtains,
Let the sun's light know
Who you are,
How long
You have been the radiating smile
On our faces,
And we weren't aware.

O mother of the beginning,
Don't end.
If a wave means nothing to fate,
The straw that is in the eye of the drowning man
Must live.

—**Mohamed Tolba**, poet

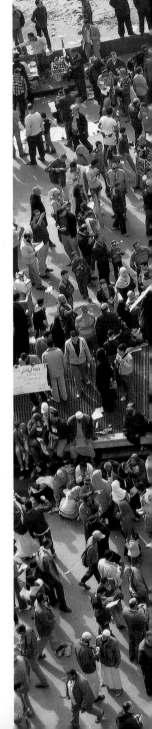

Right: Monument to the *Young Martyrs of the Tahrir Revolution.*
More than 800 people lost their lives during the revolt.

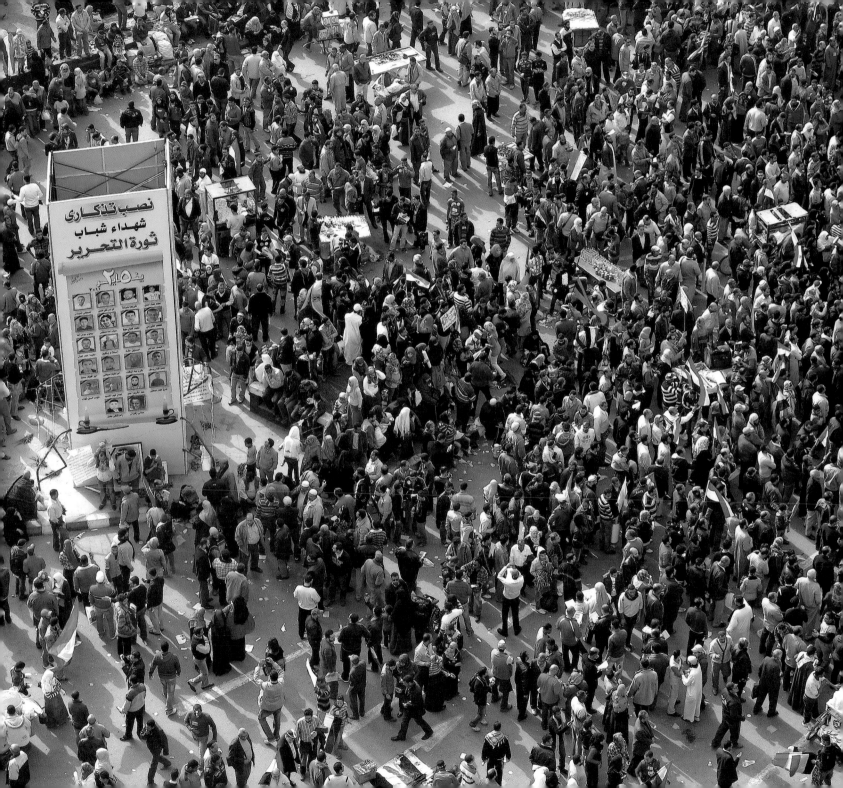

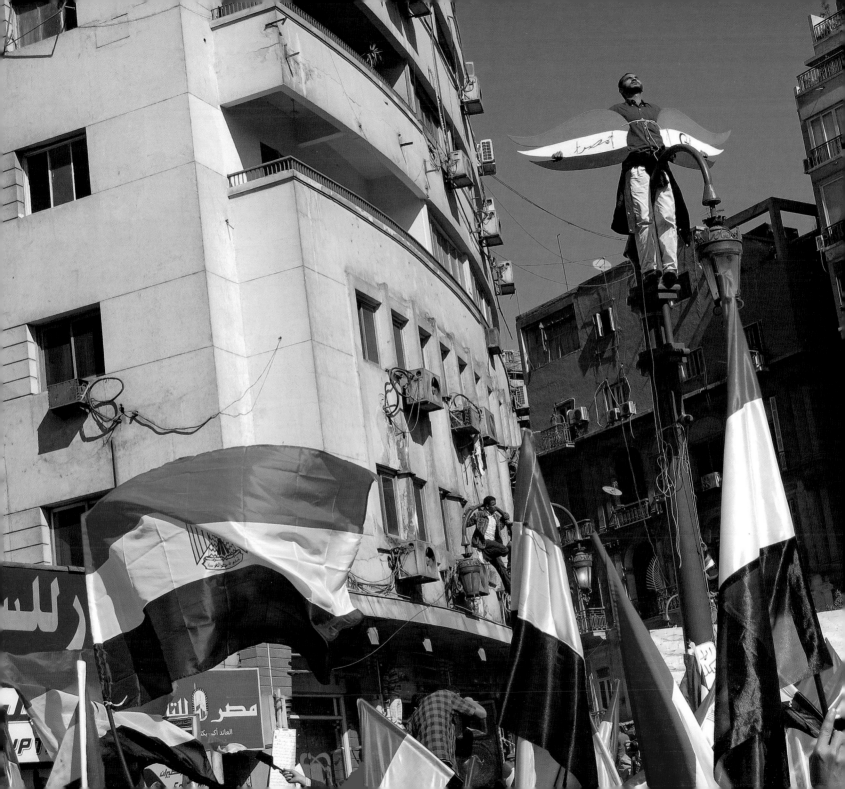

Tahrir Square turned into a 'Speakers Corner' for the Egyptian people.

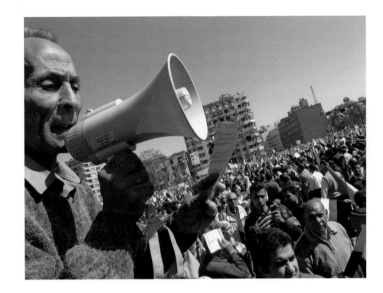

When Mubarak resigned on 11 February, power was transferred to the Higher Council of the Armed Forces.

Left: An angel for Muslims and Christians. On the angel's left wing is the joint symbol for Egypt's two main religions, a cross and a crescent brought together. On the angel's right wing the word *Tahrir* is turned into *Misr* (Egypt).

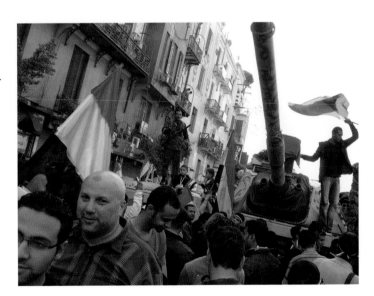

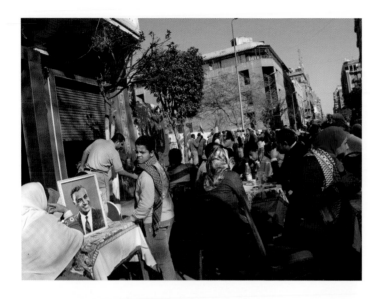

Many in Egypt still view Gamal Abd al-Nasser (the portrait on the table) as a symbol of Arab dignity and freedom. Nasser was the second president of Egypt, from 1954 to his death in 1970.

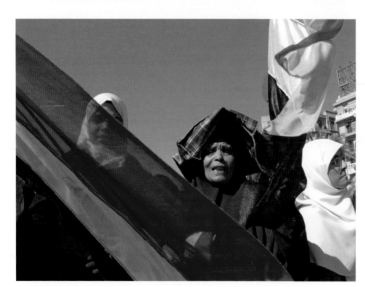

Tahrir Square became a place where all ages met, religions coexisted, and women made their voices heard.

Right: Tank guarding Qasr al-Nil Bridge, one of the many entry points to Tahrir Square.

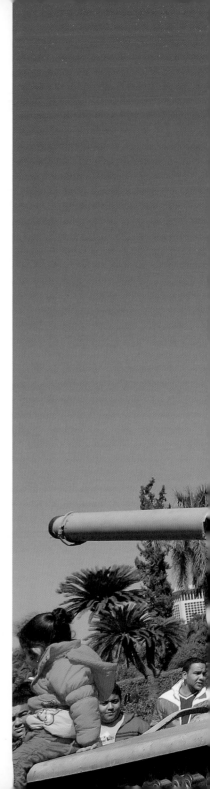

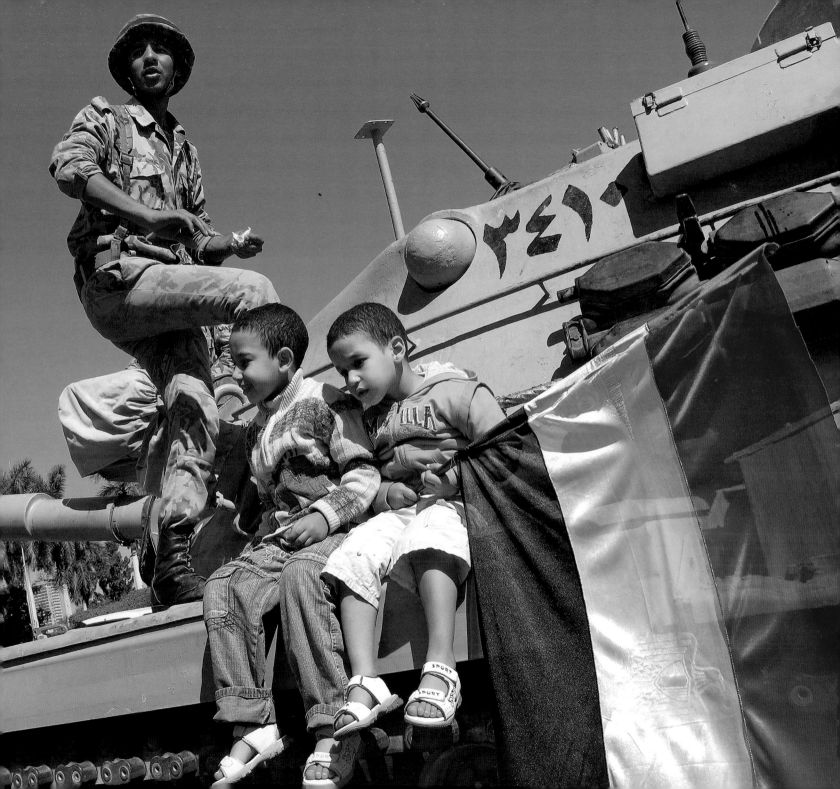

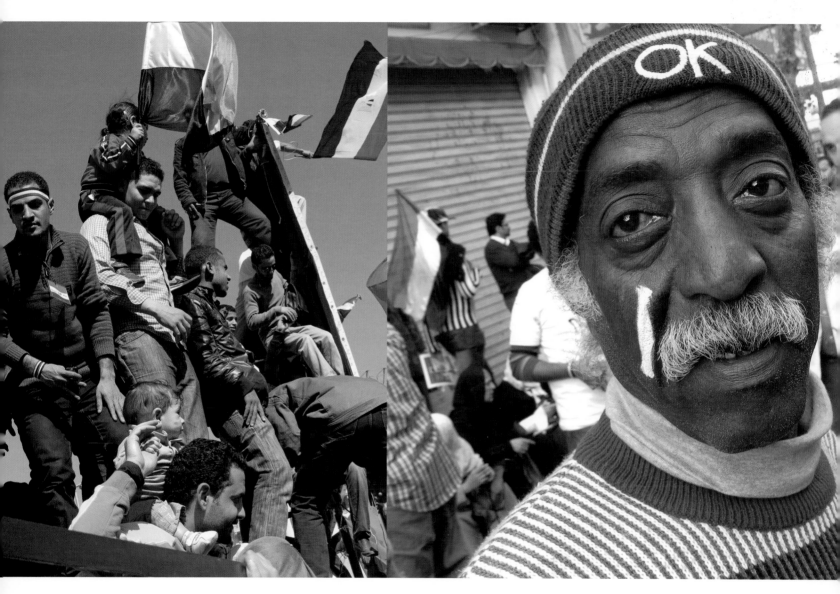

Tahrir Square, 18 February

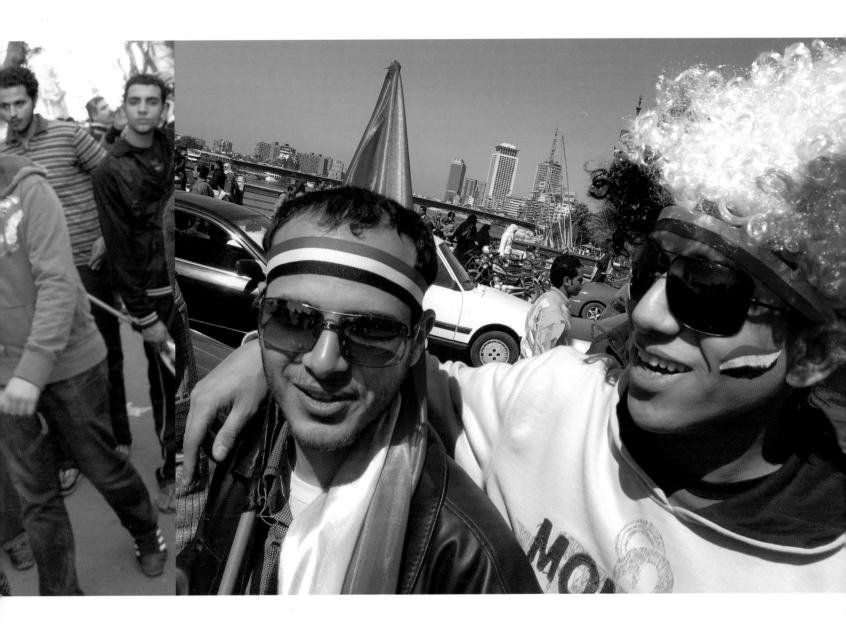

EVEN ON 24 JANUARY when someone was talking about revolution I laughed because I had completely lost faith that anything could happen to change the situation, although just a few days earlier I had written jokingly for my friends on my Facebook page that if the revolution happened I would take a bamboo chair and sit on the corner for a ringside seat. But on the 25th I knew that something momentous was happening: a determination for change and a new language had begun to appear. I found myself compelled by all my senses to plunge into this wonderful scene, though I was sad that I was not a young man to be able to share in the real action. I am proud to belong to this country.

—**Omar el Fayoumi**, artist

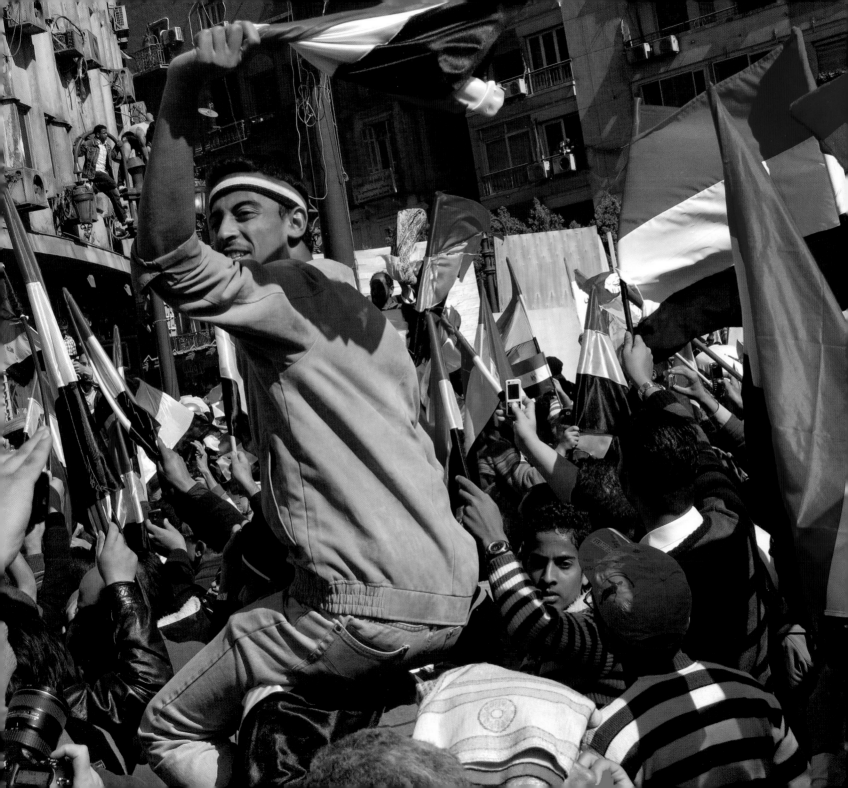

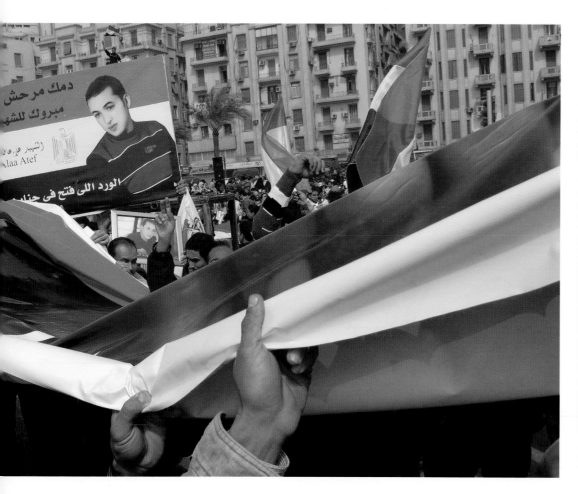

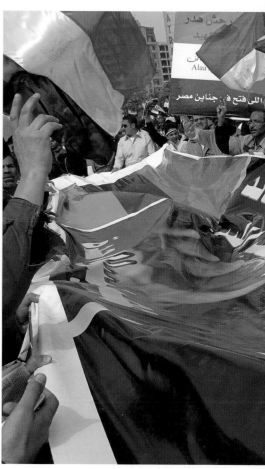

The text on the banner with the portrait of a martyr reads: *Your blood was not shed in vain*.

The banner's message reads: *The Egyptian people support the revolution of the Libyan people*.

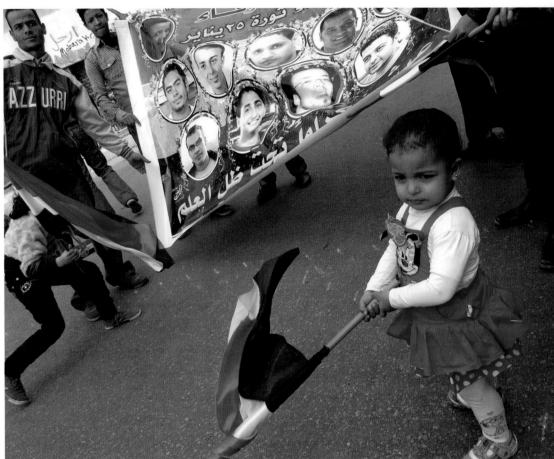

The girl is waving her flag in front of a banner honor-
ing the martyrs of the revolution.

I KNOW A YOUNG SCHOOLBOY who has never done anything but study or play football. To him it was always a big question mark why anybody would get involved in a protest or demonstration, taking the risk to get beaten or arrested for nothing. On 26 January this young boy passed Tahrir Square and decided to join the pro-democracy protesters. He was beaten, tear-gassed, hit by rubber bullets, and almost killed under the wheels of an armored car. Still, he was determined to demonstrate every day until all the demands were met and the revolution had succeeded. This young boy is my kid brother, Mohamed. He represents millions of young people who revolted to get back their Egyptian dignity.

—**Nafisa Elsabagh**, writer

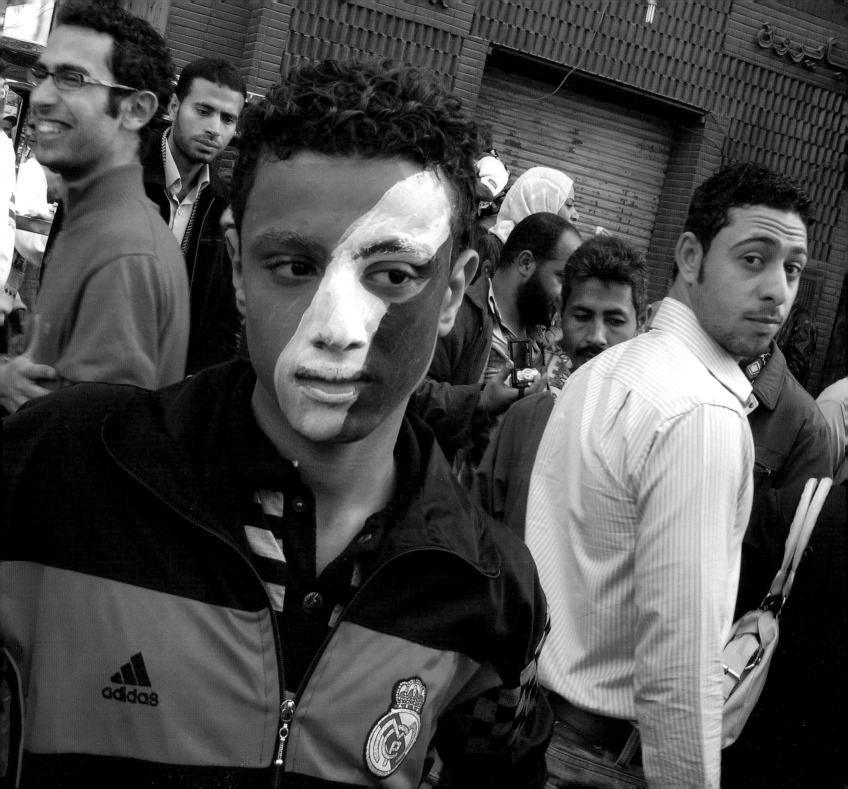

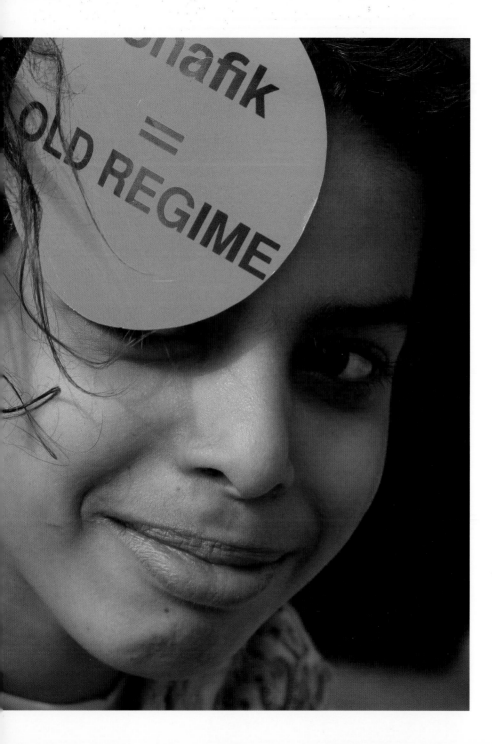

Left: A young girl wears a sticker demanding the removal of Prime Minister Ahmed Shafik, who was appointed by President Mubarak on January 29, 2011 in a bid to quell the revolt. He remained in office for only a month, resigning on 3 March.

Opposite page clockwise from top left:
On a spread from a daily newspaper showing former top-ranking government officials behind bars, this man has optimistically pasted the face of Hosni Mubarak over one of the figures in prison whites. His handwritten message above reads: *Goods spirited away: to whom it may concern.*

Egypt's emergency law was introduced after the assassination of President Anwar Sadat in 1981. It gives the Egyptian government broad powers to arrest and detain suspects without charges, refer civilians to military courts, close dissident publications, and ban demonstrations.

The placard reads: *Film of the season: Hosni Baba and the Forty Thieves. The film everyone's been waiting for. The film that personifies corruption. The film that opened on 25 January, thanks to the revolution. Directed by the people of the revolution. Showing at Tura Prison, the new presidential palace. In all the streets of Egypt.* The photograph shows the Mubarak family, left to right: Suzanne, Gamal, Alaa, Hosni.

The woman's placard reads: *To my father, my brother, my son, and all members of the Egyptian armed forces: we love you, we are proud of you, we trust you, but I am one of those who have suffered and are still suffering in this country, especially from the education system, and I want you to answer me the following: Why the determination to abort the revolution? Why the determination to waste the blood of our sons and burn the hearts of mothers for no good reason? Why, why? It's all from the education system, which has suffered the most from corruption and the corrupt, and it is still suffering now. Why Ahmed Shafiq?! Why Abu al-Gheit (snake in the grass)?! Why the continuation of the local authorities? Why the freeze on the appointment of young people and the continuation of service of pensioners so they can take bribes and be corrupt? This is the state of the education system: pay up to get what you want, in any currency (cash, honor, dignity), and if you don't pay we let loose the dogs.*

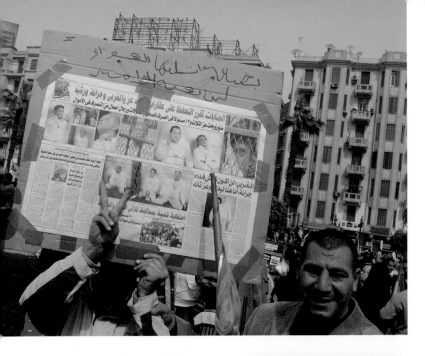

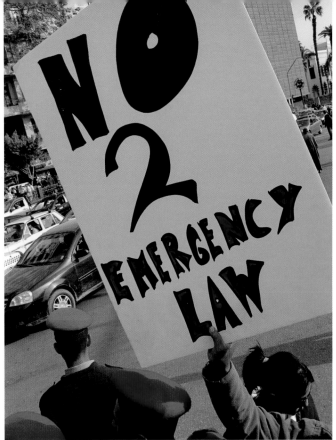

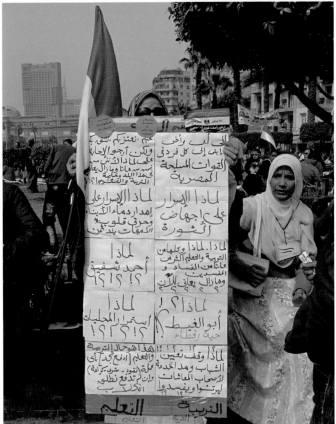

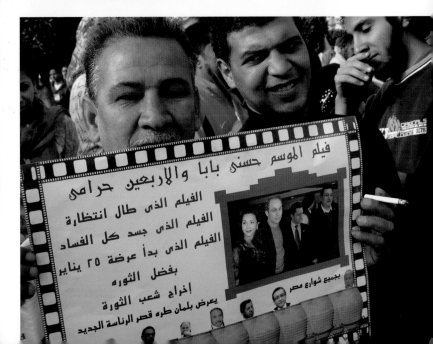

BEFORE I LEFT FOR TAHRIR, I participated in a demonstration near my family home in Imbaba. Nearby there were many women in a long queue waiting to buy bread. An old woman asked me "What's going on?" After I told her, she joined in our slogans and chants.

On my way to Tahrir, the taxi driver asked me the same question: "What's going on?" "We are going to free Egypt!" I told him. As I left the car he smiled and refused to accept payment for the ride.

—**Samia Bakry**, journalist

At Tahrir there was a solution to every problem: if the slogan is too big, just lay it out on the ground.

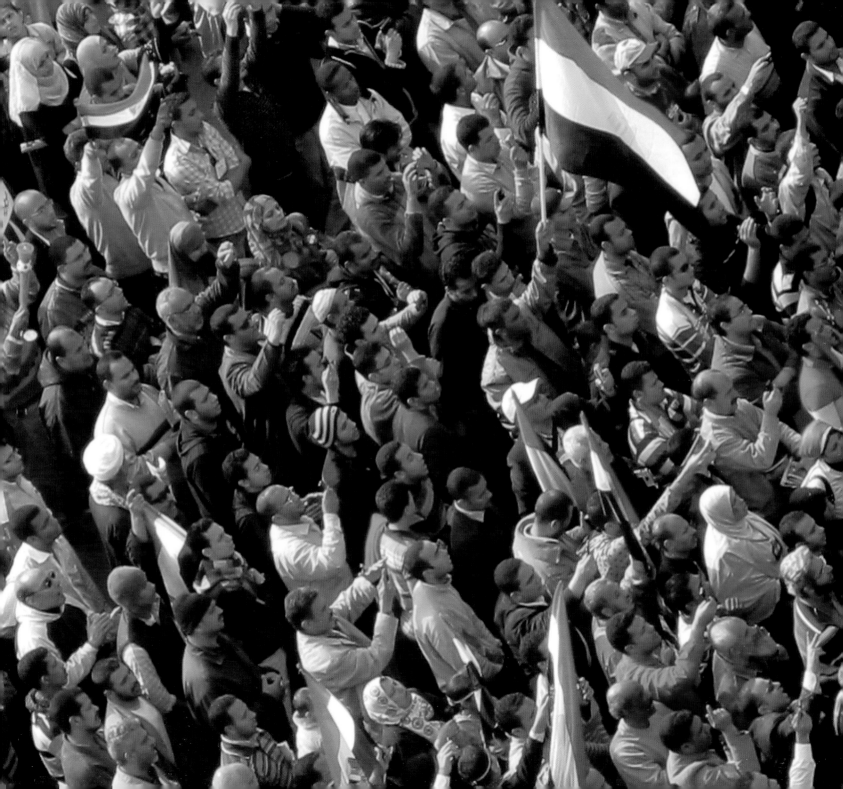

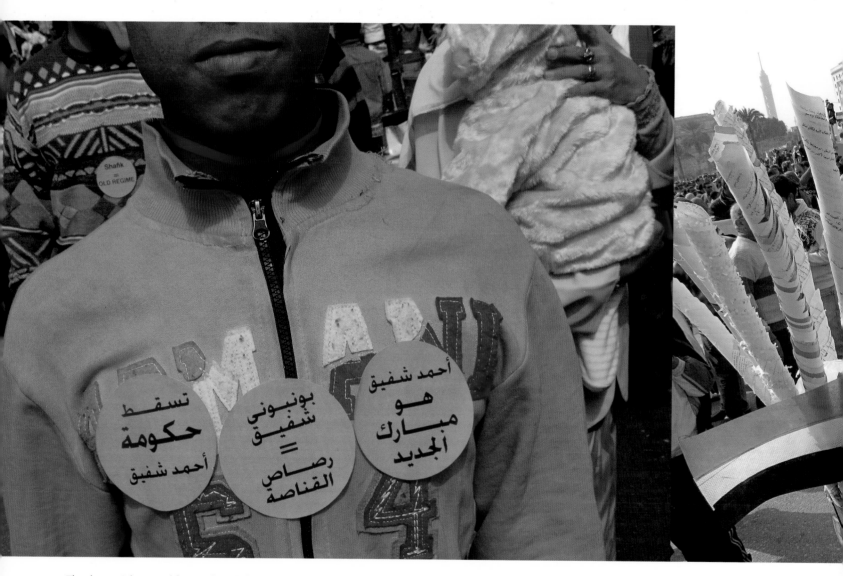

The three stickers read from right to left: *Ahmed Shafiq is the new Mubarak; Shafiq's candies = sniper's bullets; Down with the government of Ahmed Shafiq.* (Ahmed Shafiq, who was appointed prime minister by President Mubarak on January 29, 2011 in a bid to quell the revolt, had facetiously offered to give the protesters candies.)

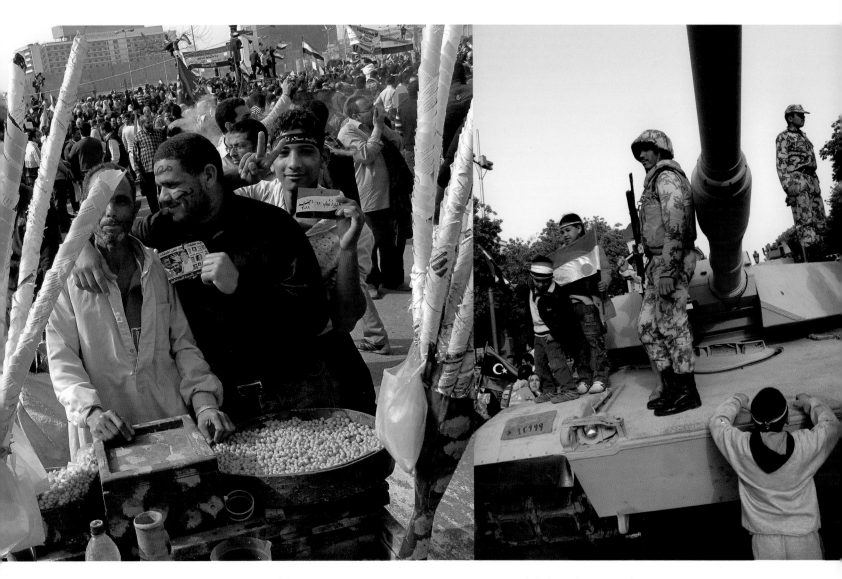

Protesters must eat, too. The man with his arm around the seller of lupin beans has *Egypt* written on his forehead, and on his cheek: *I love you.*

Most people believe the army is the protector of the revolution and want to be photographed with the soldiers.

I CAN'T STOP THINKING about all the scenes I saw on Tahrir, that truly reflect the soul of the Egyptian revolution. An old farmer was complaining that the regime was destroying Egypt's agriculture. He was determined to stay until Mubarak left, saying: "What's the worst that could happen? We will only be without food for another month. Who cares!"

And I will not forget the look on the face of an Islamist when he noticed that the young woman who was pouring water for him to wash before praying had a cross on her wrist. He joyously exclaimed: "Oh, Mubarak, you have made us love each other!"

—**Khaled Elbalshy**, journalist

Page 154: Egyptians joked that the military presence would not leave Tahrir until every Egyptian had been photographed on a tank. After the photograph, the soldier hands the boy down to his father, 28 February.

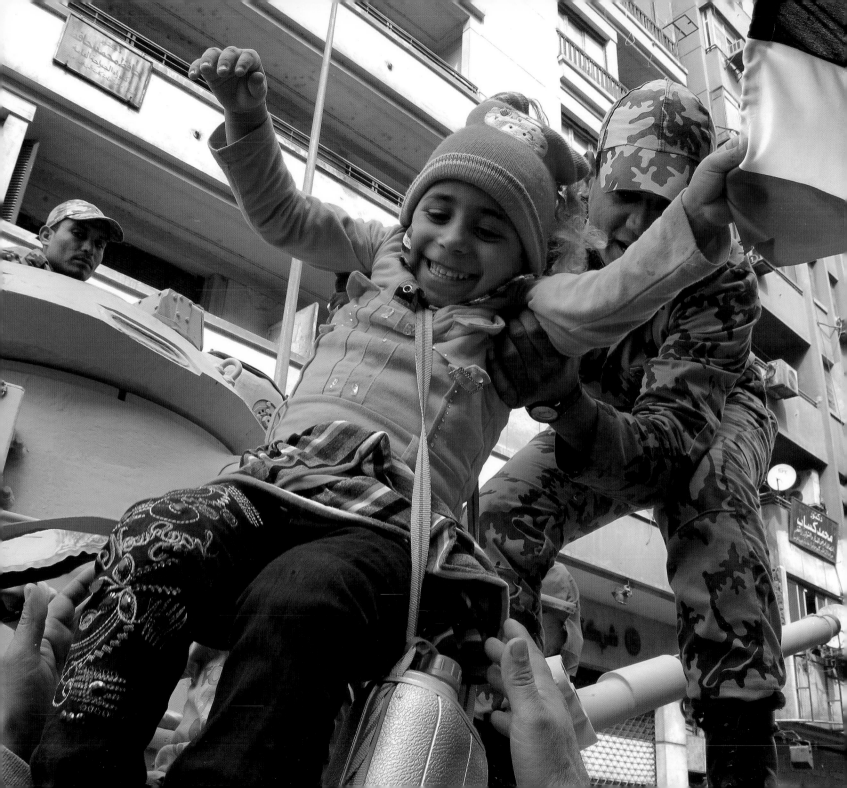